IMAGES
of America

CAPITAL REGION RADIO
1920–2011

ON THE COVER: A General Electric mascot is seated in front of a WGY Schenectady microphone in the early 1930s. (Courtesy miSci: Museum of Innovation and Science.)

IMAGES
of America

CAPITAL REGION RADIO
1920–2011

Rick Kelly and John Gabriel

ARCADIA
PUBLISHING

Published by Arcadia Publishing
Charleston, South Carolina

Printed in the United States of America

Library of Congress Control Number: 2012949768

For all general information, please contact Arcadia Publishing:
Telephone 843-853-2070
Fax 843-853-0044
E-mail sales@arcadiapublishing.com
For customer service and orders:
Toll-Free 1-888-313-2665

Visit us on the Internet at www.arcadiapublishing.com

*This book is dedicated to our families, our coworkers, our friends,
people who know what a 45 rpm record is, and, especially, to
all of you that love that wonderful medium called radio.*

CONTENTS

ACKNOWLEDGMENTS

Rick Kelly and John Gabriel would like to thank those who have helped assist with material for this book. They loaned us their time, their photographs, and their knowledge of Capital Region radio. For that, we are grateful.

We thank Chris Hunter of MiSci: Museum of Innovation and Science in Schenectady, Lou Roberts, Chip Ordway, Kip Kirby, Joe Condon, Richie Norris, Jay Scott, Albany Broadcasting Co., Donna Halper, Peter Kanze, Clear Channel Radio of Albany, Town Square Media, and YNN/Time Warner Cable, Albany.

Unless otherwise noted, all images appear courtesy of miSci: The Museum of Innovation and Science.

INTRODUCTION

The history of radio in New York's Capital Region is a rich one. It began in 1920 in Schenectady with General Electric and its early experiments. One of America's first radio stations, WGY, became such a household name in the 1920s and 1930s that "WGY grocery stores" and products appeared throughout Upstate New York. Farmers in remote rural areas relied on WGY's daily farm reports. Everyone wanted a radio set. They were hooked on that little box that kept them connected to the world.

Today, WGY remains on the air with its original call letters, and it is one of the most powerful radio stations in the country. With 50,000 watts, WGY covers half of America, and parts of Africa and Europe at night. WGY's parent company, GE, manufactured radio receivers, built shortwave stations, and set up the nation's first broadcast network, NBC.

But that is only the beginning. By 1922, WGY was joined by WHAZ in Troy, a station built and operated at Rensselaer Polytechnic Institute. WHAZ remains on the air to this day with its original call letters.

WXKW 850 AM, a once-powerful station, was forced to sign off after only a few years of operation due to conflicts with GE. WXKW was resurrected in the 1960s as a small station at 1600 AM. Today, it is gone. But many others survive. WOKO in Albany was joined by WABY, whose original transmitter location remains on Braintree Street in Albany. The station is now a part of Northeast Public Radio.

By April 1940, WTRY in Troy hit the airwaves as a daytime-only operation at 950 AM. Its former transmitter site was located in Latham. Several years later, WTRY would receive a power increase and move to 980 AM, where it remains today as a sports station with new call letters. WTRY remained in its original studios at the Proctor's Theatre building in downtown Troy until 1978.

However, it was the great "Top 40" radio wars that are most remembered among baby boomers. WPTR 1540 AM signed on in 1948, and by the late 1950s, it had joined WTRY by playing Top 40 rock 'n' roll. Everyone had their favorite station. One was either a WPTR fan or a WTRY fan. But folks probably listened to them both equally. The on-air personalities that introduced the region to Elvis, the Beatles, Motown artists, and many others made listeners keep that transistor under their pillows at night. WPTR's "Boom Boom" Brannigan, probably the best-known of all radio disc jockeys during the 1960s, remained a familiar favorite until his death in 2010. He was the king of self-promotion, and people talk about him to this day. Sadly, his happy chatter graced the airwaves of WPTR for only about 10 years. WTRY's Lee Gray, the self-proclaimed "Beatle buddy," gave the audience exclusive songs and interviews with the Fab Four. WTRY sent busloads of listeners to the famous concerts at Shea Stadium to see the Beatles. On November 9, 1965, the great Northeast blackout occurred, which plunged all of New York State and parts of Pennsylvania and Canada into darkness. Many thought that the Russians had dropped the atomic bomb. WTRY was the only Capital Region radio station that remained on the air, thanks

to a standby generator. WGY, owned by GE, a company that manufactured generators, could not get up and running until 90 minutes later. As a result, WTRY provided a great public service and received an award from the White House and Pres. Lyndon Johnson. Don Weeks, one of the most popular local personalities, began his career in the early 1960s doing mornings at WTRY. He also did television weather at WAST channel 13. But he remained in local radio all those years. His longest tenure was on the morning show at WGY, from which he retired just a few years ago.

Radio was at its peak in the Capital Region and throughout the country by the 1970s. The radio wars between WTRY and WPTR went on until the early 1980s, when WPTR finally gave up its Top 40 format in favor of country and western. After that, the station changed hands many times. Today, it no longer operates with its original 50,000 watts, and it is on the air only part-time.

FM radio in the Capital Region was late in developing. Much of that was due to the local terrain of hills and valleys, which pose problems for FM signals. Only a few stations stood out initially. WGY's sister station WGFM, along with WFLY in Troy, were among the first on the FM dial. But eventually, stations like WFLY, WGFM, and WPYX made their mark, and there was no going back. In the 1970s, many FM stations were owned by AM stations, which kept the FM concerns afloat. That turned around in the 1980s.

Today, the Albany-Schenectady-Troy radio dial boasts over 40 different stations, in contrast to 10 stations in the 1970s. There is still music on the AM side. WROW, at 590, plays oldies, and there was WABY 1160 in Mechanicville and a few more in the rural areas. But music on FM remains king. And then there is the Internet. This book, however, will not concern itself with that medium. This book is a tribute to the days when radio was live, local, and fun to listen to.

Some local radio fans, upon reading this book, might say, "Hey, you missed this and that." And that would be true. Believe it or not, acquiring images of Boom Boom Brannigan proved to be the most difficult. Some behind-the-scenes photographs were just not available, and some were so expensive as to be beyond reach. There is so much more to say, and we know it. Perhaps someday, enough material can be gathered for a second volume, called *Capital Region Radio Revisited*.

We do hope you enjoy the memories we've collected here. The two of us grew up together in the village of Waterford, about eight miles north of Albany, New York. We both fell in love with local radio and the music it played and the personalities that presented it. This book has been a labor of love, and we hope it means as much to you as it does to us.

One

1920–1940

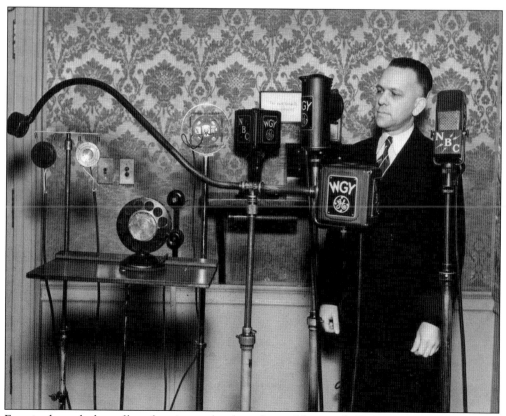

Even in the early days of broadcasting, technology changed frequently. WGY station manager Kolin Hagar stands with many of the microphones he used over his long career with the station. Hagar was WGY's first announcer, conducting the very first broadcast at WGY on February 20, 1922.

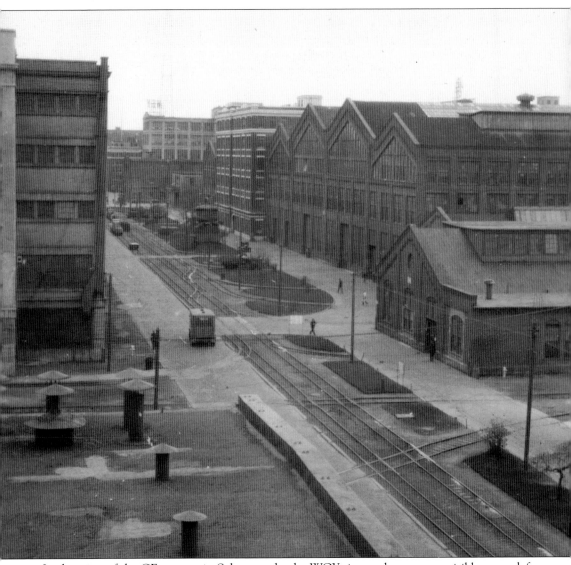

In this view of the GE campus in Schenectady, the WGY sign and towers are visible at top left. WGY broadcast from GE Building 40 during the early 1920s.

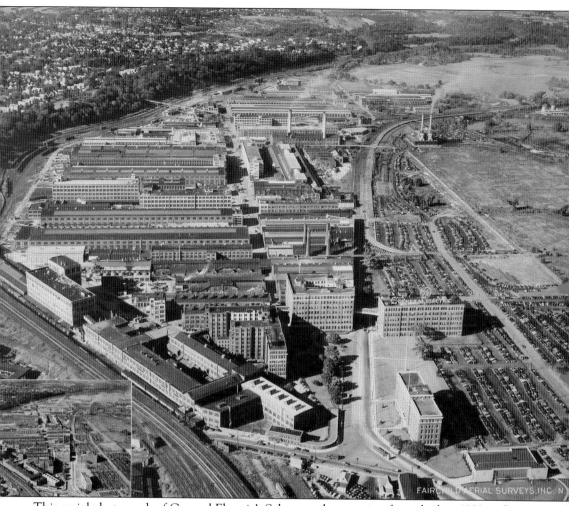

This aerial photograph of General Electric's Schenectady operation from the late 1930s reflects the size and scope of a company approaching its zenith.

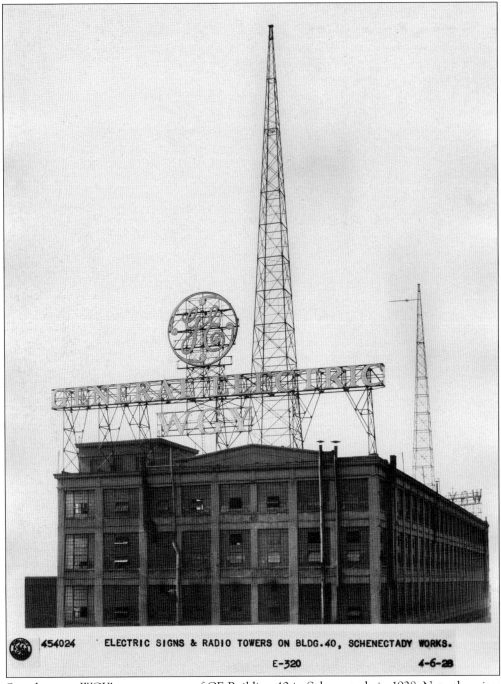

454024 ELECTRIC SIGNS & RADIO TOWERS ON BLDG.40, SCHENECTADY WORKS.

E-320 4-6-28

Seen here are WGY's towers on top of GE Building 40 in Schenectady in 1928. Note the wires strung between the towers, a common means of transmission in the 1920s. The station transmitter was relocated to South Schenectady in 1925.

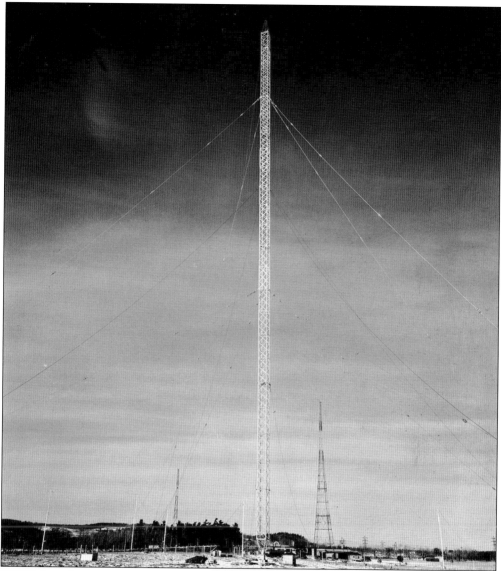

WGY's broadcast tower was constructed in 1938 in Rotterdam (South Schenectady). In the distance are two free-standing towers used for transmission from 1925 until the installation of the single tower in 1938.

RADIO BROADCASTING STATION

WGY

SCHEDULE FOR JANUARY & FEBRUARY

MUSICAL PROGRAMS *Meters*

Every Monday, Tuesday, Thursday and Friday afternoon 2:00 to 2:30; evening 7:45
Special late program Friday evenings at 10:30.

SUNDAY PROGRAMS
10:30 a.m. and 4:30 p.m.

CHILDREN'S STORIES
Every Friday evening at 6:30

WEEKLY HEALTH TALKS
Every Friday evening at 7:40

NEWS BULLETINS
Daily, except Saturday and Sunday, 6:15 p.m.

N. Y. STOCK EXCHANGE REPORTS
Daily, 12:30 p.m. except Sunday.
Daily, 6:00 p.m., except Saturday and Sunday

General Electric Company Band

U. S. NAVAL OBSERVATORY TIME SIGNALS
Daily, 11:55 a.m. and 9:55 p.m.
Wednesday and Saturday, 11:55 a.m. only. No time signals Sunday

OFFICIAL WEATHER FORECAST
Daily, except Sunday, 12:45 p.m., on 485 meters

TIME REFERENCE
Eastern Standard. Changes in schedule announced by Radiophone.

N. Y. PRODUCE MARKET REPORTS
Daily, except Saturday and Sunday, 12:30 and 6:00 p.m.

GENERAL ELECTRIC COMPANY, Schenectady, N. Y., U. S. A.

January, 1923

PC-?44-10th Edition

This WGY program schedule from 1923 was undoubtedly distributed by mail to listeners who wrote in to the station. Note the scheduling of time signals and weather forecasts.

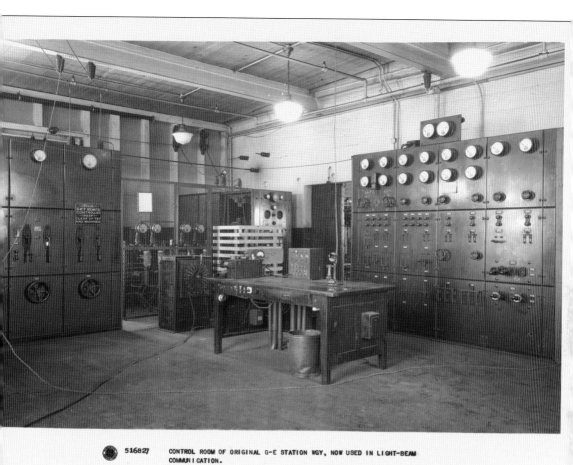

By the mid-1930s, radio station transmitters were more sophisticated, with dangerous electronic equipment contained in safer cabinets. This photograph shows the WGY transmitter control room in 1934.

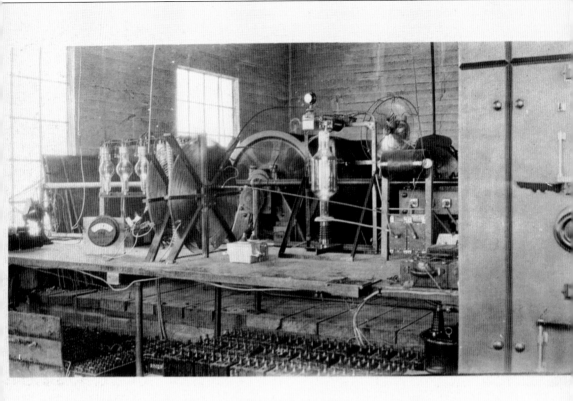

 402599 RADIO BROADCASTING STATION W. G. Y. BUILDING NO. 40.
INDEX 654

This is another view of the WGY transmitter from the 1920s. Wiring, coils, and meters were left exposed for easy access, maintenance, and repairs. Repairing such high-voltage equipment was delicate and dangerous.

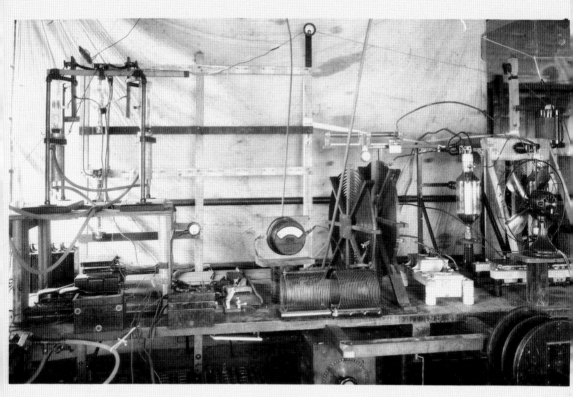

This crude mass of wires, tubes, power meters, transformers, and coils was actually the transmitter for WGY in 1922. General Electric employees called this unit "The Powerhouse." Note the electric fan pointed at the large power tube in the right portion of the photograph, undoubtedly used for cooling.

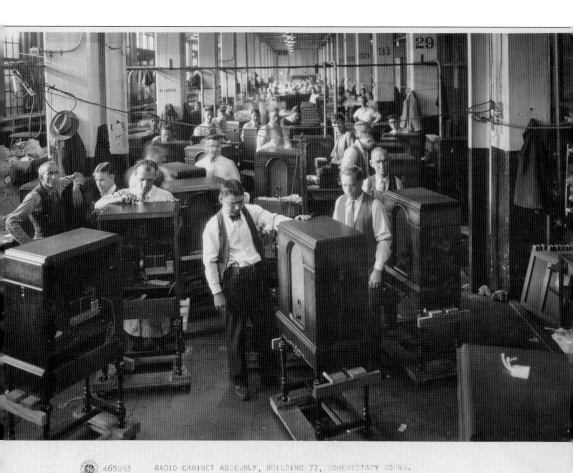

Schenectady GE Building 77 teemed with radio assemblers in the 1920s. The struggle to keep up with the manufacture of RCA radio sets kept dozens of technical and furniture workers busy, even during the Great Depression of the 1930s.

1027 802 1921 VERSION OF A "PORTABLE" RADIO RECEIVER (BABY-CARRIAGE RADIO).

FILING NO.6918 E384 728.3 9-27-46

In 1921, students at Schenectady's Union College, with the help of General Electric, assembled the first portable radio. Union College's experimental station, 2XQ, provided the signal. Reportedly, the carriage was pushed around the city of Schenectady for purposes of publicity. 2XQ was a forebear of the college's station, WRUC.

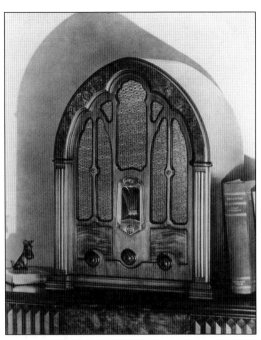

A product of General Electric's Schenectady manufacturing operation was this stunning "Cathedral" radio from 1932.

This is one of the first portable radios, made by GE for RCA. It measured just five and a half inches tall.

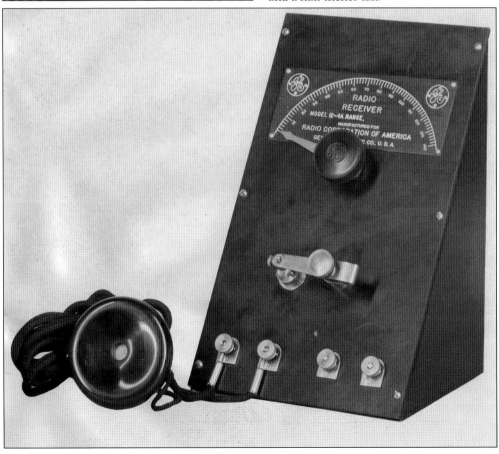

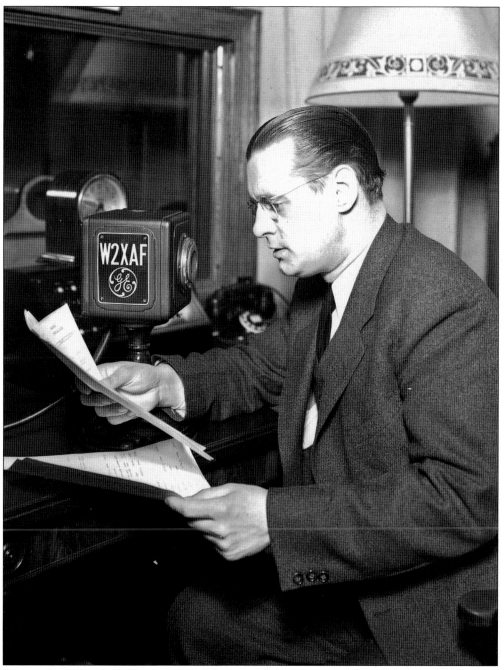

During the 1930s, WGY experimented and established shortwave broadcasting from General Electric's headquarters in Schenectady. The shortwave stations later became known as WGEO and WGEA. An unidentified announcer reads on the air in this undated photograph.

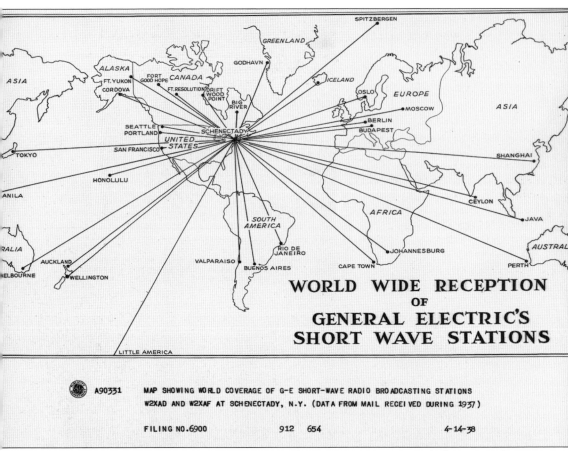

WORLD WIDE RECEPTION
OF
GENERAL ELECTRIC'S
SHORT WAVE STATIONS

A90331 MAP SHOWING WORLD COVERAGE OF G-E SHORT-WAVE RADIO BROADCASTING STATIONS
W2XAD AND W2XAF AT SCHENECTADY, N.Y. (DATA FROM MAIL RECEIVED DURING 1937)

FILING NO. 6900 912 654 4-14-38

In publicizing its experimental shortwave broadcasting stations, General Electric used a map of the world indicating the reach of the stations, based on actual reports of reception around the world.

Shortwave broadcasting from the GE studios in Schenectady became increasingly important to oversees audiences when World War II began. Here, the staff of WGEO and WGEA handle war news. Shown are, from left to right, Luis Gonzaga, Eugene Darlington, manager of stations John Sheehan, program manager Luiz Malheiros, Prof. Vincent Tovar, Gertrude Beyan, and Jose Flores.

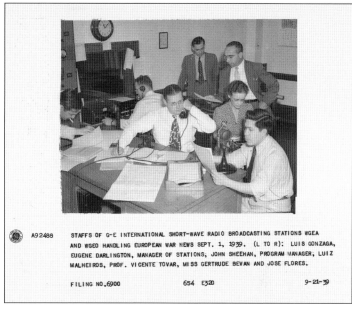

STAFFS OF G-E INTERNATIONAL SHORT-WAVE RADIO BROADCASTING STATIONS WGEA AND WGEO HANDLING EUROPEAN WAR NEWS SEPT. 1, 1939. (L TO R): LUIS GONZAGA, EUGENE DARLINGTON, MANAGER OF STATIONS, JOHN SHEEHAN, PROGRAM MANAGER, LUIZ MALHEIROS, PROF. VICENTE TOVAR, MISS GERTRUDE BEVAN AND JOSE FLORES.

FILING NO. 6900 654 E320 9-21-39

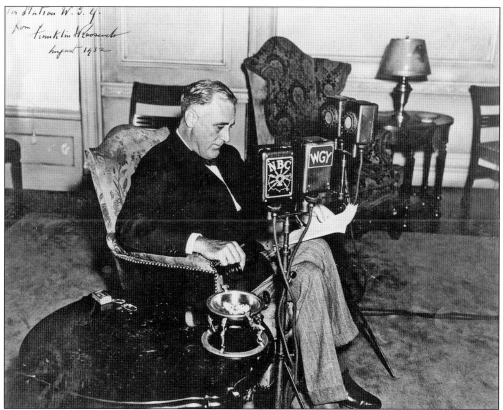

WGY, along with the NBC Radio Network, broadcast from the home of Franklin Delano Roosevelt in Hyde Park, New York, in August 1932. Only months later, Roosevelt was elected president of the United States, winning by a landslide and defeating standing president Herbert Hoover. Roosevelt was sworn in as president in March 1933.

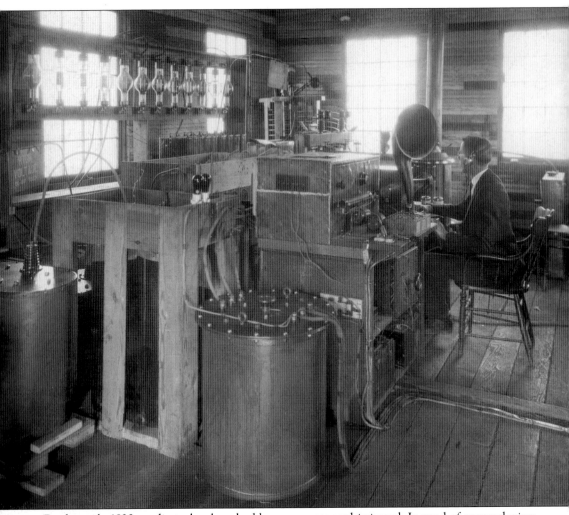

By the early 1930s, radio technology had become more sophisticated. Instead of exposed wires, gauges, coils, and other dangerous apparatus, cabinets held and organized the individual components of transmission equipment. Shown here is the WGY control room in the early 1930s.

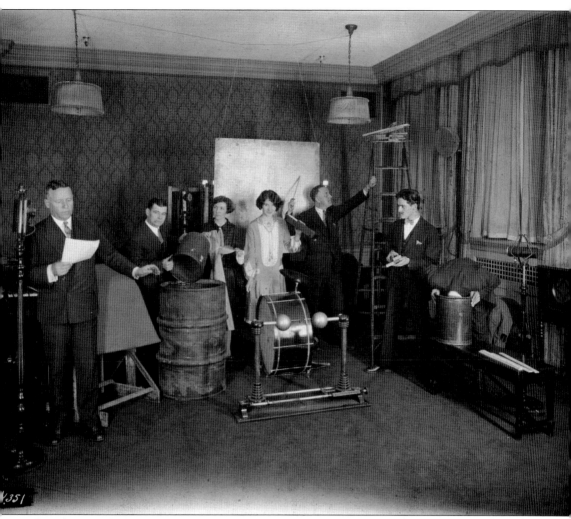

This photograph demonstrates the elaborate productions the WGY Players conducted in the 1920s. This production appears to include the sounds of material poured in a barrel, the tearing of cloth, rattling, and thunder. The man on the right with his head in a bucket, presumably of water, is probably simulating the sounds of a drowning man.

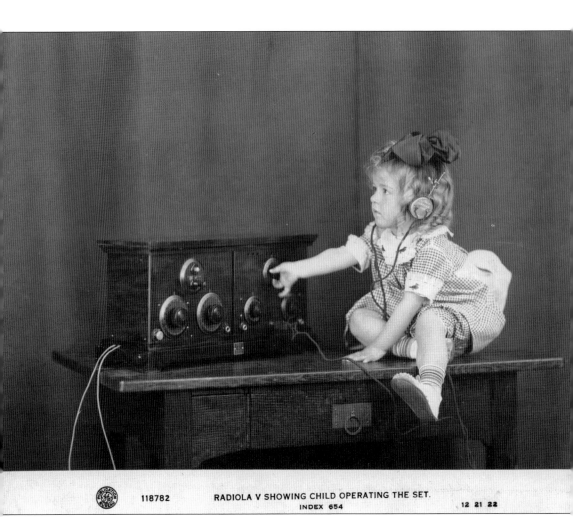

A young girl poses listening to a Radiola V unit, manufactured in Schenectady by General Electric.

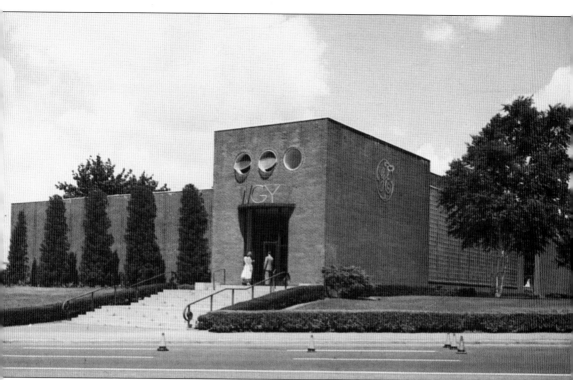

In 1938, WGY's studios moved from Building 36 at General Electric to a new Art Deco building, as seen in this postcard. In 1961, the station moved to Balltown Road. The striking River Street building was demolished as part of the construction of I-890.

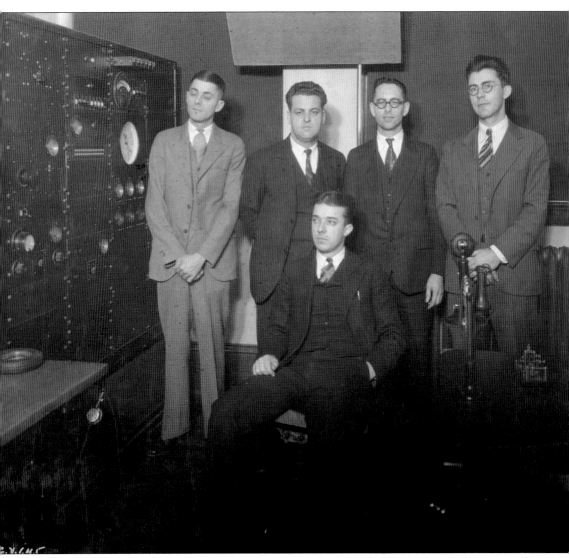

The WGY engineering staff poses for a photograph in the early 1930s. The gentleman standing on the right is Willard J. Purcell, one of the original radio pioneers at WGY. Purcell, who worked for WGY for 38 years, prepared the very first radio log for the station when it went on the air on February 20, 1922.

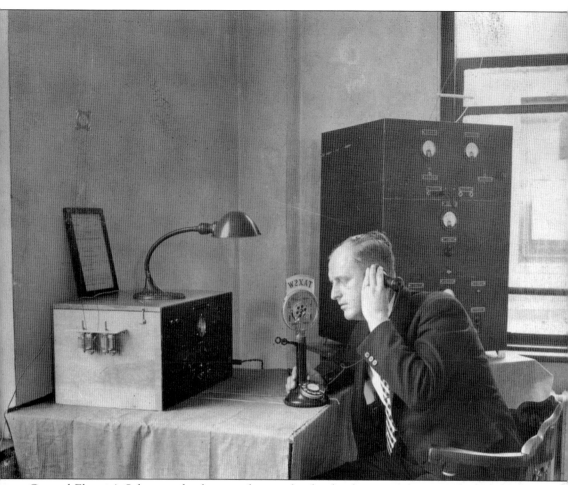

General Electric's Schenectady plant was known for the development of new products. In this photograph, GE engineer M.A. Salamon demonstrates the use of transmitting equipment for police and fire departments. Note the telephone/microphone combination being used.

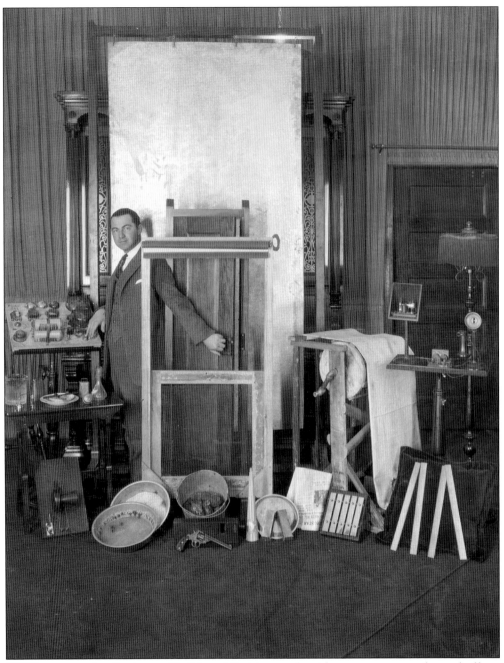

WGY's master of radio drama, H. Edward Smith, stands with an assortment of sound effects devices used for the station's radio productions.

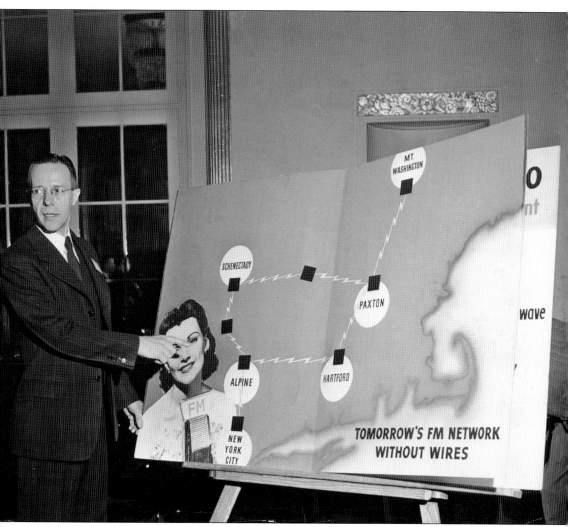

Edwin H. Armstrong developed FM broadcasting in the 1930s. When the medium came on the scene in the 1940s, it made static-free, long-distance broadcasting possible. GE engineer W.R. David supported Armstrong's plan to construct a network without wires through New York and New England, using Armstrong's Alpine, New Jersey, station as the flagship. Similar networks of FM stations were formed in the 1960s, with WFLY networking with WQXR in New York.

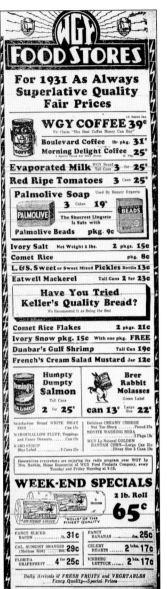

WGY's force as a media powerhouse actually produced a small grocery store chain. With the blessing of GE management, WGY Food Stores opened in the late 1920s. The chain at one point comprised over 100 stores, mostly located in towns bordering the Mohawk River. (Courtesy Chip Ordway.)

By the late 1920s, the call letters "WGY" had become a household word, and it was the brand name for a Capital Region grocery store chain. By 1930, the WGY Food Store chain had grown to 130 small grocery stores, all within 75 miles of Schenectady. Other businesses used the WGY name as well, including the WGY Refrigeration Company and the WGY Coin Shop.

WGY Spanish olives (right) were one of the many food items available at local WGY grocery stores. WGY coffee (below) kept the Capital Region wide awake in the 1920s and 1930s. (Both, courtesy Chip Ordway.)

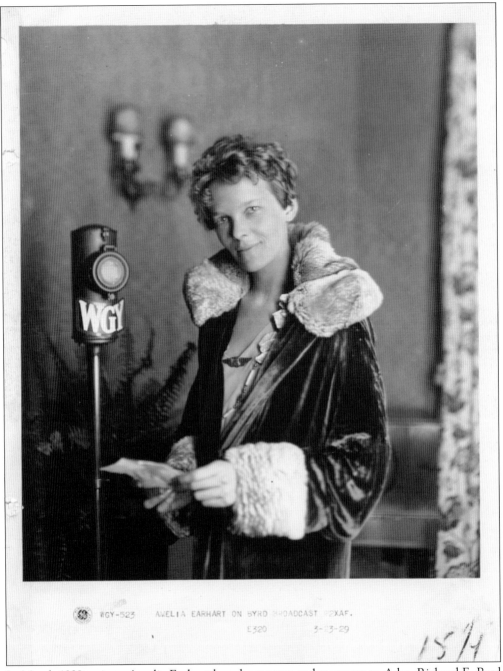

In March 1929, aviator Amelia Earhart broadcast news and messages to Adm. Richard E. Byrd during his famous expedition to the Antarctic. Even though her broadcast was technically over shortwave W2XAF, Earhart posed at the WGY microphone. In 1937, during an attempt to circumnavigate the globe, Earhart's plane disappeared over the central Pacific Ocean.

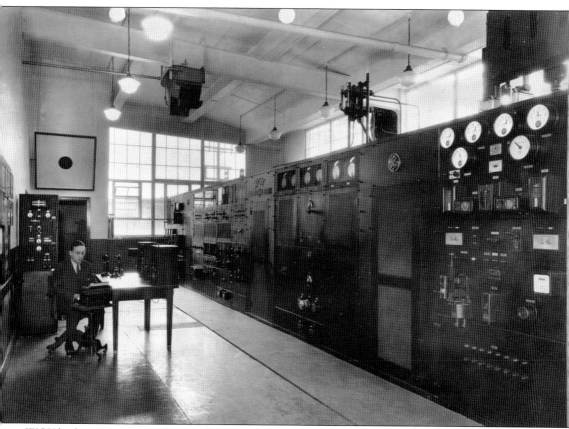

WGY had completed installation of a state-of-the-art, 50,000-watt transmitter in 1932. The large gauges on the right of the transmitter measure various voltages along with sound and power output. A chief operator was needed to constantly monitor the transmitter to ensure voltage and wattage tolerances were maintained. The transmitter model was a General Electric RT-152-K.

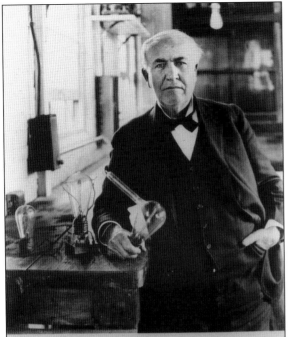

Thomas A. Edison with his "Edison Effect" lamps. The inventor's discovery of the "Edison Effect" in 1880 revealed the fundamental principle on which rests the modern art of electronics.

Thomas Edison's invention of the light bulb led directly to the invention of the vacuum tube. Edison was a founder of the General Electric Company in Schenectady. He was the preeminent genius of his time, famous for the quote, "Genius is one percent inspiration and ninety-nine percent perspiration."

Dr. Charles Steinmetz was a world-renowned electrical research scientist for the General Electric Company at the beginning of the 20th century. He fostered the development of alternating current and was most famous for his experiments creating artificial lighting. General Electric had a building the size of a football field for this pioneering research. At the time, Steinmetz was as well known as Thomas Edison and George Westinghouse.

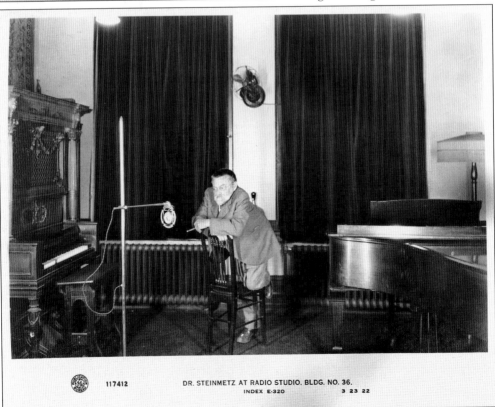

117412 DR. STEINMETZ AT RADIO STUDIO. BLDG. NO. 36.
INDEX E-320 3 23 22

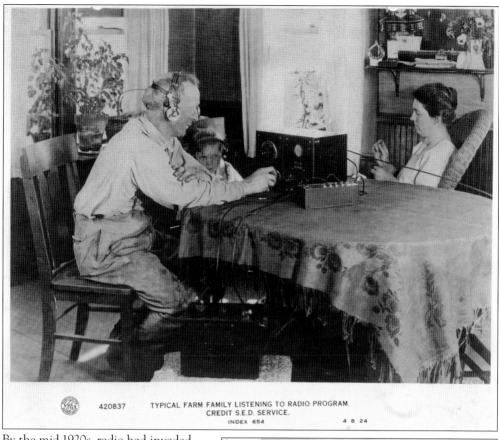

TYPICAL FARM FAMILY LISTENING TO RADIO PROGRAM.
CREDIT S.E.D. SERVICE.
INDEX 654 4 8 24

By the mid-1920s, radio had invaded even the most rural communities. Note the family members wearing headphones, which was the earliest way to listen. When this photograph was taken in 1924, amplified speakers were still a luxury.

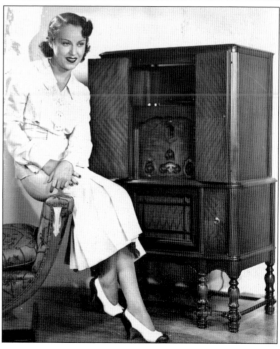

This 1934 GE advertising photograph shows how home radios had progressed since the early, more experimental days. Radios could now be built into attractive pieces of furniture and were powered by a regular wall plug, as opposed to batteries.

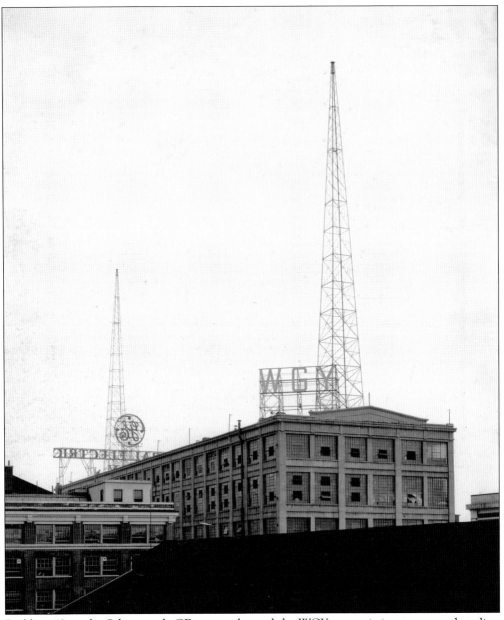

Building 40 on the Schenectady GE campus housed the WGY transmission towers and studios. Just visible in this photograph is the wire antenna between the two towers.

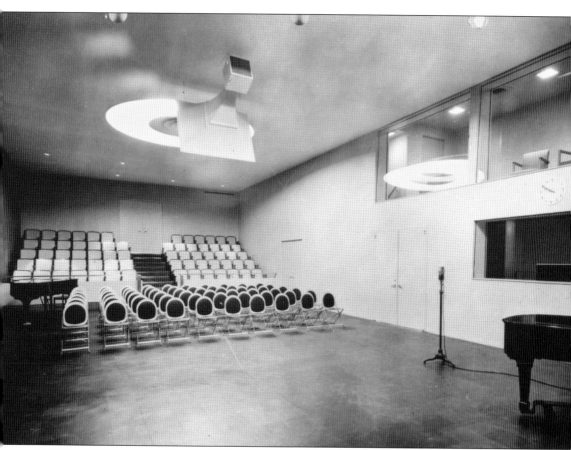

WGY's move to new studios in 1936 meant a more modern facility, able to accommodate well over 100 audience members.

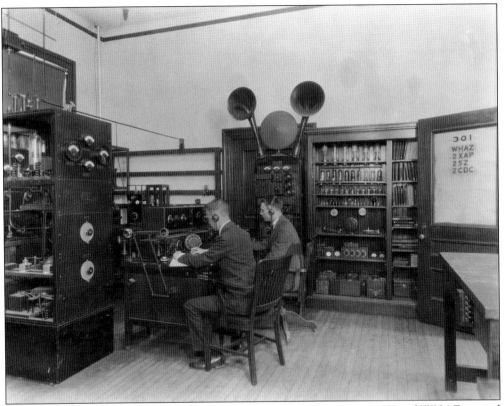

In the early 1920s, there were two radio stations in the Capital Region, WGY and WHAZ, owned and operated by Rensselaer Polytechnic Institute. Early on, WHAZ actually shared the same spot on the dial as WGY. WHAZ operated one day per week, and WGY the other six days. The above photograph shows the transmitter control room. The transmitter and studio were located in the Russell Sage Labs. (Courtesy RPI Library.)

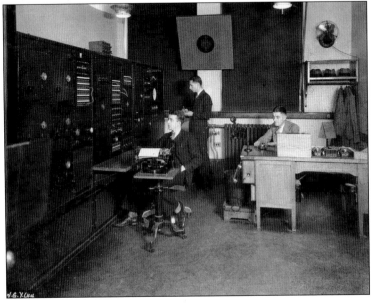

By 1930, WGY's control room had a more contained, modern look.

Two

EARLY RADIO STARS

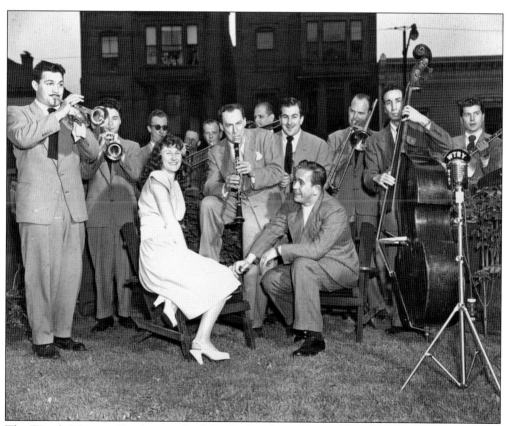

The Woody Herman Band serenades John Bachinski and his girlfriend, Helen Ivanyshyn, in an early-1950s event sponsored by WTRY.

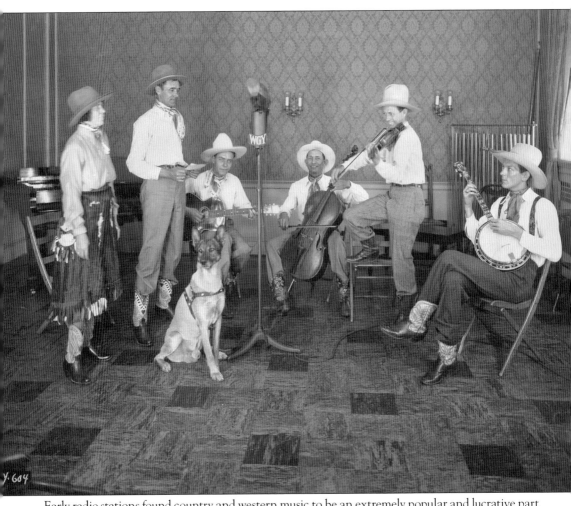

Early radio stations found country and western music to be an extremely popular and lucrative part of the program day. Alto Gray and the Cowboys were a popular feature on WGY in the 1920s.

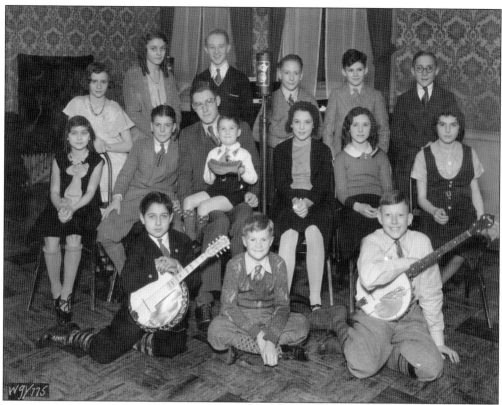

The WGY Junior Players pose with program manager Kolin Hagar in the late 1920s. Precocious young performer Sonny Salad sits on Hagar's lap.

Martha Brooks reported daily and performed hundreds of interviews during her long tenure at WGY, which lasted from 1931 to 1971. Brooks, whose given name was Irma Lemke, also did reporting for WGY's associated television station, WRGB.

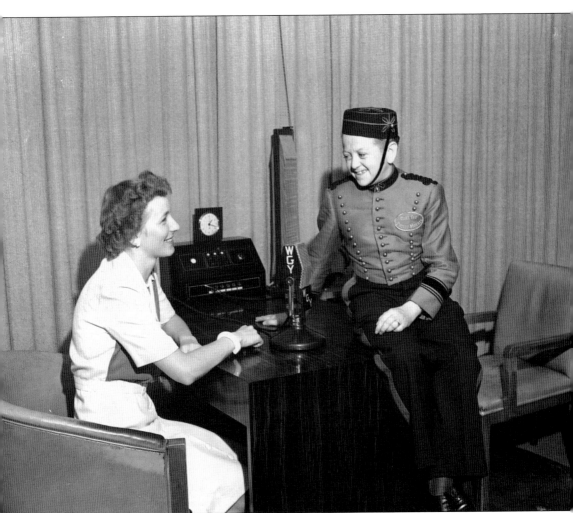

WGY announcer Betty Lennox chats on the air with Johnny Roventini, who was nationally known as the spokesperson for Philip Morris cigarettes. Dressed as a diminutive bellhop, his phrase, "Call for Philip Morris," was heard on radio for years.

President of General Motors Charles E. Wilson (left) and GE scientist Philip K. Reed stand with a rather large WGY microphone in this 1940 photograph. Note the man's feet at the base of the microphone.

On a cold winter's day in the early 1920s, the National Biscuit Company Band proudly stands outside Schenectady's GE Building 36. The original WGY studios were located in this building. The National Biscuit Company later became Nabisco.

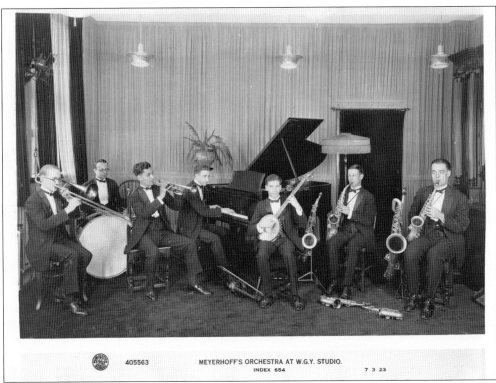

405563 MEYERHOFF'S ORCHESTRA AT W.G.Y. STUDIO.
INDEX 654 7 3 23

The WGY Orchestra serenaded listeners several times a week throughout the 1920s. The name of the orchestra changed often. At various times, it was called the NBC Orchestra, the GE Orchestra, and the WGY Orchestra.

WGY was one of the first, if not the first, radio station to offer radio drama, and it pioneered the use of sound effects to enhance storytelling. The pictured production is *A Stormy Night in the Catskills*. Sound effects include, from left to right, bowling ball and pins emulating the sound of thunder; pails and pans used for pouring water; a large metal sheet, which was moved for additional sounds of thunder; and a tumbler device, which was filled with small rocks or uncooked beans to imitate the sound of rain.

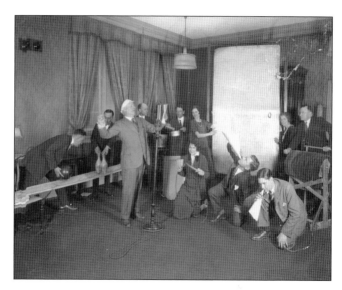

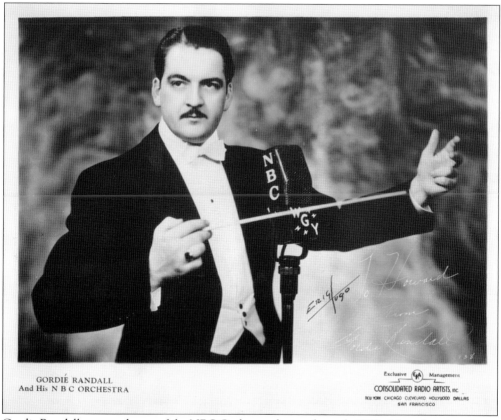

GORDIÉ RANDALL
And His N B C ORCHESTRA

Exclusive (GA) Management
CONSOLIDATED RADIO ARTISTS, INC.
NEW YORK CHICAGO CLEVELAND HOLLYWOOD DALLAS
SAN FRANCISCO

Gordie Randell was conductor of the NBC Orchestra during the early 1920s. Note the microphone boasting both NBC and WGY.

George Lazotte was not only a news reporter for WTRY. He served as an announcer as well. Lazotte worked for WTRY at least twice, and he also worked at WABY. Lazotte is seen here in a publicity shot for the station.

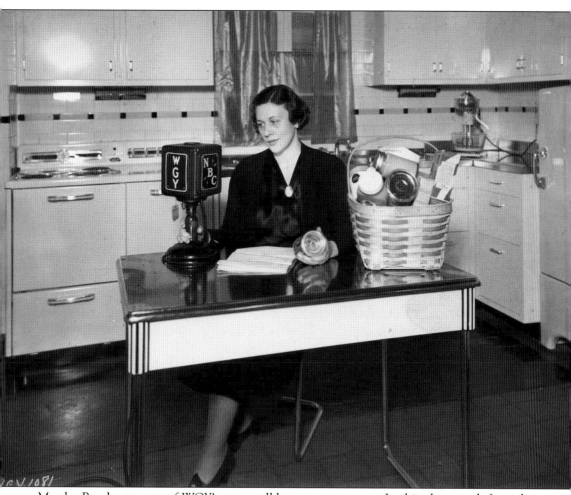

Martha Brooks was one of WGY's most well-known announcers. In this photograph from the early 1930s, she broadcasts from her stylish General Electric appliance kitchen.

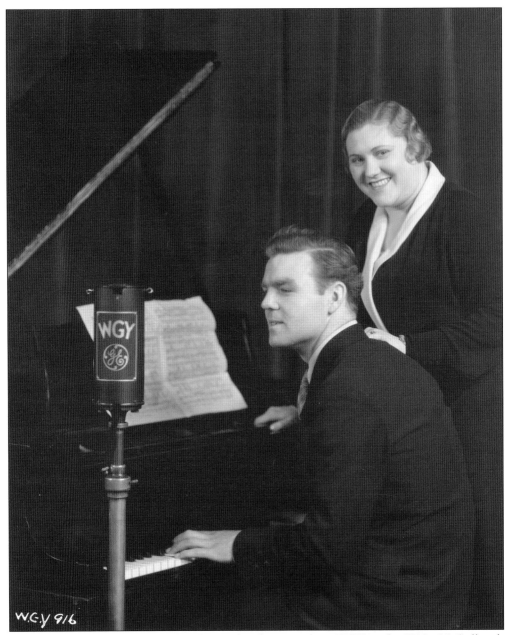

Jerry Coyle and Annette McCullough were familiar singers on WGY in the 1930s. McCullough was known as "the girl with the voice like blue velvet." Coyle remained with WGY until his retirement in 1969.

H. Edward Smith was an actor with a theater group in Troy called The Masque in 1923 when he suggested to WGY program manager (and former actor) Kolin Hagar that plays could be effectively presented on radio. Hagar agreed, and radio drama was born in the Capital Region. Such presentations were duplicated all over the country, and WGY became the pioneer of radio drama.

Here, Smith poses with the various bells used in dramatic broadcasts. The small door was used to produce the sounds of opening and closing doors.

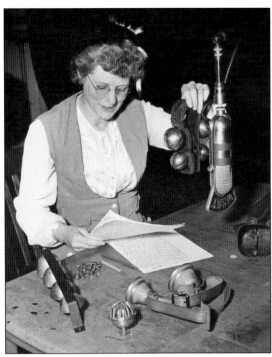

During the 1940s, Schenectady station WSNY featured a radio program for fourth-, fifth-, and sixth-graders known as the *4-5-6 Club*. Here, Katherine Turnbull acts as the music reporter for the program.

In an effort to promote varied programming and to increase listenership for their sponsors, many stations in the 1920s and 1930s offered several different orchestras. WGY offered the All-Girl Orchestra during that era.

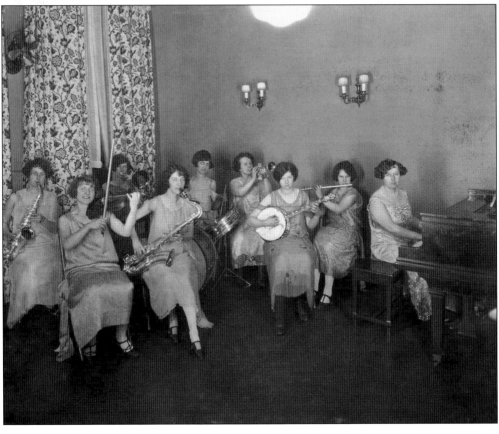

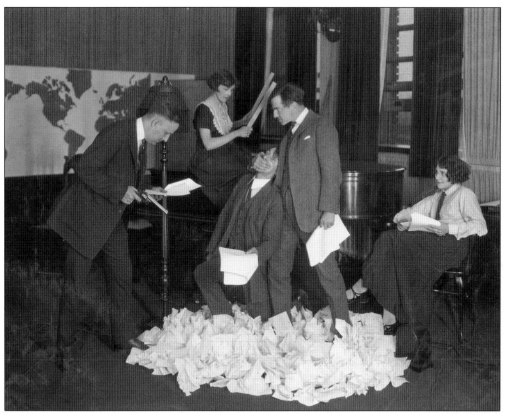

WGY's talent for assimilating sound effects in dramatic presentations is illustrated in this photograph from the production of *Prairie of the Plains*. Announcer Kolin Hagar holds a gun—hopefully filled with blanks—while actor Edward Smith trudges through a field of leaves and holds his hand over his victim's mouth.

By 1929, the WGY Orchestra started using interchangeable names, depending on the circumstances. Alternate names included the NBC Symphony Orchestra and, in this photograph, the GE Symphony Orchestra.

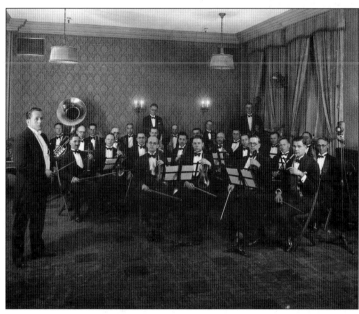

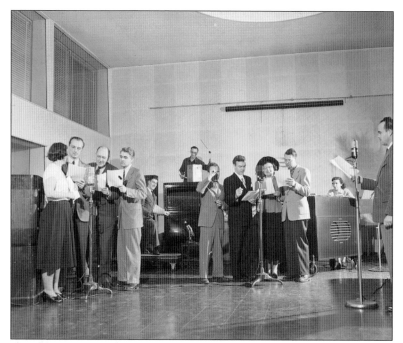

The FBI in Action was a program produced by WGY starting in 1943. It lasted until the early 1950s.

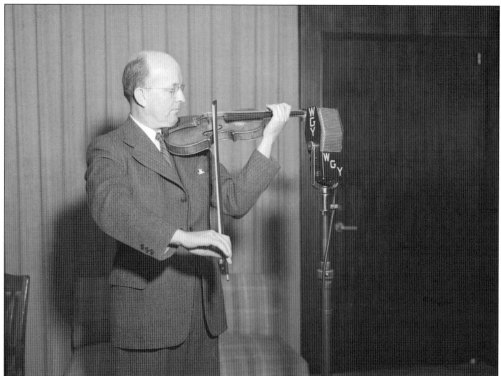

Edward A. Rice, the premier violinist on WGY, had a national reputation for his virtuosity. Rice inspired young people to practice and play the violin with skill and professionalism. He also worked for the Albany Symphony Orchestra and taught at Skidmore College and the Emma Willard School at the College of St. Rose in Albany. He later became conductor of the WGY Orchestra.

A youngster named Sonny Salad was one of the more precocious members of the WGY Junior Players. He started with the group when he was four years old, and he played clarinet, saxophone, and flute. He later played with Fats Waller's band, the Claude Thornhill Orchestra, and other swing artists.

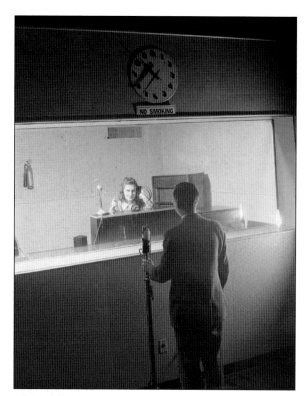

During World War II, women emerged in occupations traditionally held by men. WGY engineer Elizabeth Bauer held a position that enabled her to do research into proper microphone technique. She also performed more traditional engineering tasks.

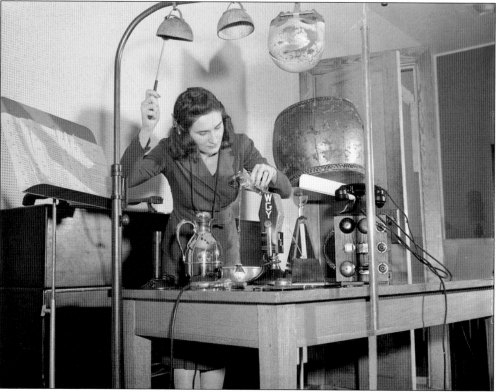

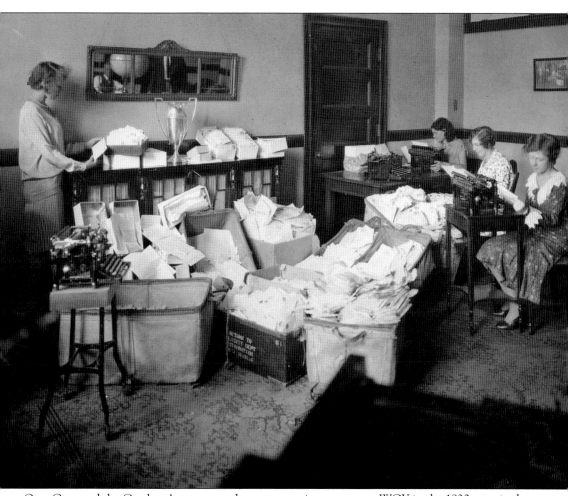

Otto Gray and the Cowboys' country and western music program on WGY in the 1930s required the station to hire a staff to open and answer the mail. Country and western, more commonly known then as "hillybilly" music, generated huge audiences across the United States.

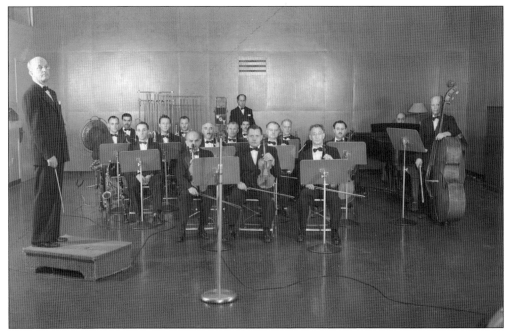

Conductor Edward A. Rice (left) poses with the WGY Orchestra in this photograph from the 1940s.

Earle Pudney worked in several capacities for General Electric Broadcasting for decades. Besides being the morning announcer of WGY during the 1940s, he hosted a live dinner-hour television program called the *Earle Pudney Show*, which aired from 1958 to 1967 on WGY's sister television station, WRGB.

The *WGY Radio Ranch* was a popular program that occupied the 1:00 hour each day. The program was famous for showcasing the talents of Ernie and Cindy Lindell, Speedy Wyman, and Marion Bruno. The program was the forerunner to the popular *Pete Williams Show* in the 1960s on WRGB-TV. This 1950s photograph features singers Otis and Eleanor Clements.

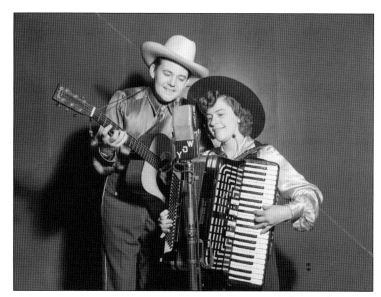

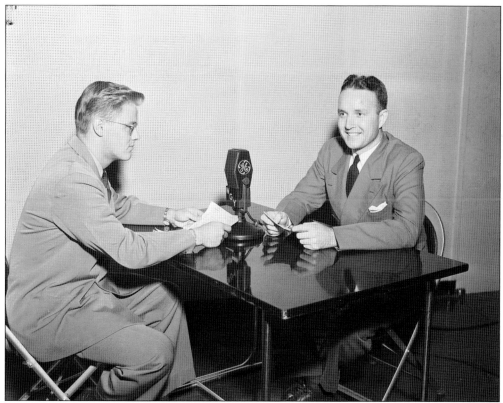

WGY announcer Bob Hanes (left) interviews agent Jack Wilcox of the FBI for WGY's *The FBI in Action* program. In the late 1940s, Wilcox wrote a report for the FBI regarding the alleged sightings of UFOs in Washington State. This photograph was taken in 1943.

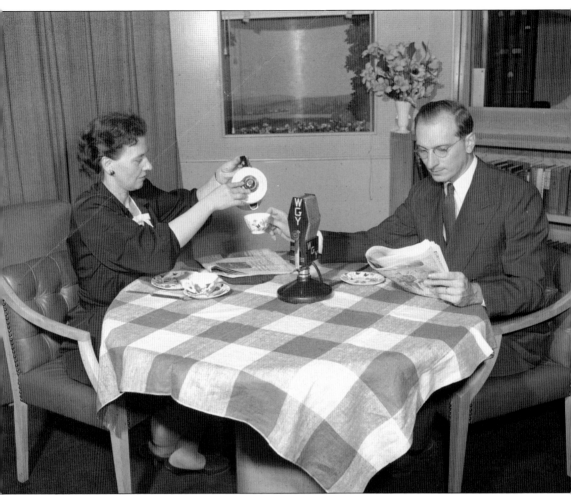

In this publicity photograph, WGY morning personalities Martha Brooks and Dave Kroman have breakfast on the air. As with many WGY personalities, Brooks and Kroman worked on General Electric's television station. Kroman hosted a high school quiz show, *The Little Red Schoolhouse*, on WRGB. Brooks and Kroman were married in real life. Note how Kroman cannot pull himself away from the newspaper as Martha Brooks pours his coffee.

Three

1941–1955

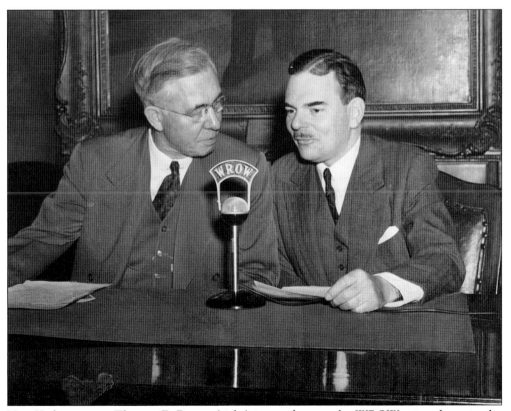

New York governor Thomas E. Dewey (right) is seen here at the WROW microphone in the late 1940s.

Roy Shudt was a famous sports announcer for WTRY in the early 1950s. Coming over from WROW, he was probably best known as an announcer at Saratoga Raceway and, later, at Brandywine race track in Delaware. He was known for his opening call of "Herrre they come!"

Martha Brooks, an outstanding and longtime reporter, dealt with women's issues on WGY. Here, Brooks reports from a hospital bed during a Red Cross blood drive.

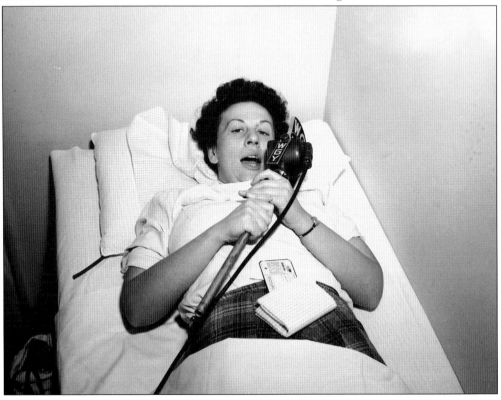

In the early 1950s, WTRY did large-scale promotions in association with local advertisers. Standard Furniture in Troy advertised faithfully on WTRY until the 1990s. The man standing at center, in front of the giant microphone, is well-known WTRY sports announcer Roy Shudt.

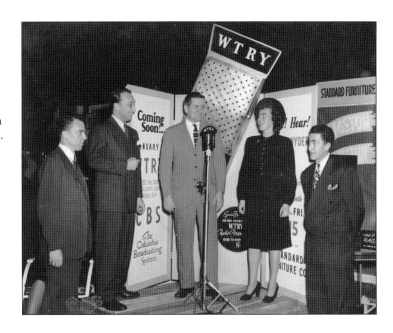

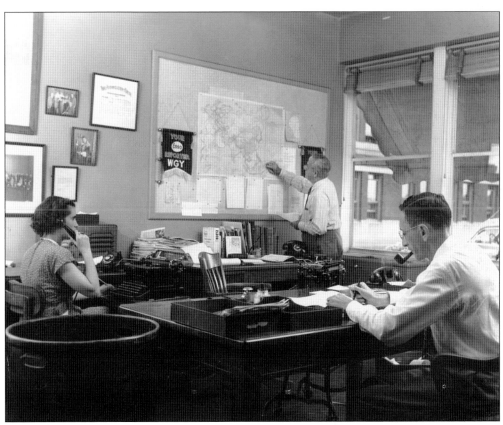

Today, the sight of three people working in a radio newsroom is rare. Seen here in the WGY newsroom in the late 1940s are Florence Zimmer (left), Lansing Christman (center), and Bill Meeham.

In The Heart of the Great Northeast

790

45 50

WGY

50,000 WATTS

THE POWER TO REACH
THE PRESTIGE TO SELL

768,800

RADIO

FAMILIES

WGY BROADCAST ADVERTISING
IS BUILDING SALES EVERY DAY!

A REPRESENTATIVE WILL GLADLY CALL
WITHOUT OBLIGATION

WGY — 1 RIVER ROAD, SCHENECTADY, N. Y.

NATIONAL BROADCASTING CO., INC.

The North American Radio Broadcasting Agreement of 1941 affected almost every radio station in the country. The treaty, made by Canada, the United States, and Mexico, expanded the AM band from 550–1500 kilocycles to 540–1600 kilocycles. As a result, stations broadcasting on 790 were required to move to 810 on the dial. Other Capital Region stations affected by the treaty were WTRY and WOKO.

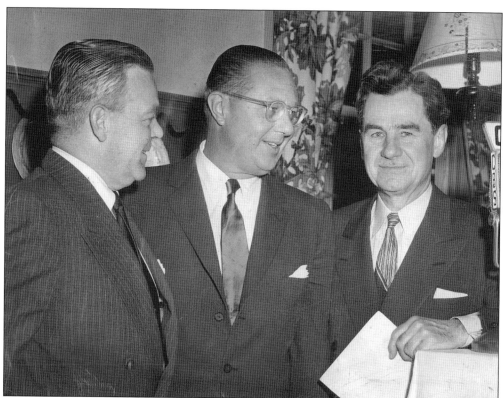

In the mid-1950s, broadcaster and author Lowell Thomas purchased a small broadcasting company in the Capital Region that included WROW. The company, later becoming Capital Cities Communications, bought the ABC network in 1986. This photograph features Thomas (right), along with New York congressmen Leo O'Brien (center) and Dean Taylor. (Courtesy Joe Condon.)

In 1949, WGY covered the induction ceremony and Hall of Fame Game in Cooperstown, New York. Baseball commissioner Branch Rickey spoke at the ceremony. The young man at the left is WGY's Howard Tupper.

The WGY personalities pose for a publicity shot in 1952. They are, from left to right, Martha Brooks, Charles John Stevenson, Bob Bender, Earle Pudney, and secretary and production director Janet Fletcher.

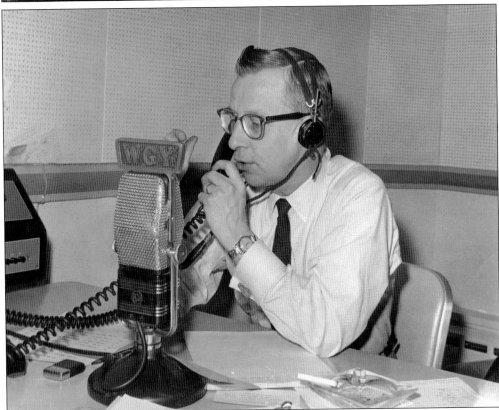

Howard Tupper was a reporter, weatherman, and announcer for WGY and WRGB-TV. His three decades of broadcasting include many years at WGY. In addition to a long stint as a weatherman, he was the host for channel 6's bowling program, *TV Tournament Time*. "Tupp" was known for his on-air greeting of "Hi, small fry."

The WTRY neon sign, delineating the location of their offices and studios in the Proctor's Theatre building, was an icon in downtown Troy. It remained there for years after WTRY had left the city.

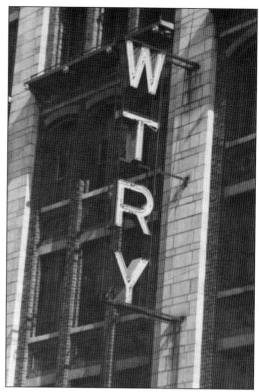

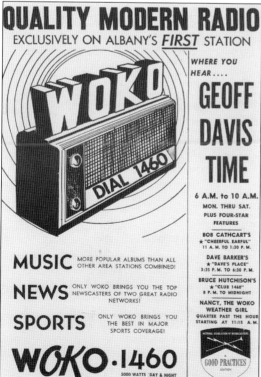

QUALITY MODERN RADIO
EXCLUSIVELY ON ALBANY'S *FIRST* STATION

WOKO
DIAL 1460

WHERE YOU HEAR....

GEOFF DAVIS TIME

6 A.M. to 10 A.M.
MON. THRU SAT.
PLUS FOUR-STAR
FEATURES

BOB CATHCART'S
★ "CHEERFUL EARFUL"
11 A.M. TO 1:30 P.M.

DAVE BARKER'S
★ "DAVE'S PLACE"
3:35 P.M. TO 6:30 P.M.

BRUCE HUTCHISON'S
★ "CLUB 1460"
8 P.M. TO MIDNIGHT

NANCY, THE WOKO
WEATHER GIRL
QUARTER PAST THE HOUR
STARTING AT 11:15 A.M.

MUSIC MORE POPULAR ALBUMS THAN ALL OTHER AREA STATIONS COMBINED!

NEWS ONLY WOKO BRINGS YOU THE TOP NEWSCASTERS OF TWO GREAT RADIO NETWORKS!

SPORTS ONLY WOKO BRINGS YOU THE BEST IN MAJOR SPORTS COVERAGE!

WOKO · 1460
5000 WATTS ·DAY & NIGHT

NATIONAL ASSOCIATION OF BROADCASTERS
GOOD PRACTICES
STATION

WOKO started as a small station in New York City in 1924. In 1928, the station moved to Beacon Falls, about 40 miles north of New York City. The station had little success and was sold and moved to Albany in 1930, with considerable fanfare. The station was an affiliate of the CBS Radio Network until 1947, when it lost affiliation to upstart station WTRY. In the 1950s, WOKO was largely an independent station playing middle-of-the-road music. Announcer Geoff Davis had found popularity on WROW in the middle and late 1950s. In the 1960s, he worked as morning personality at WOKO. This print advertisement of the day expresses the confidence that WOKO management had in Davis as morning announcer. (Courtesy Joe Condon.)

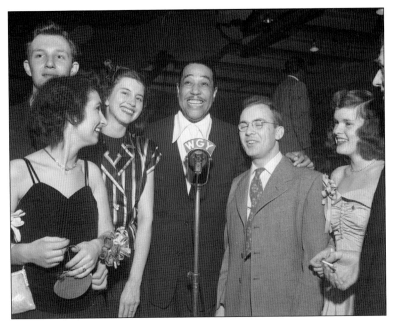

WGY newsman
Howard Reig
shares a laugh with
big band leader
Duke Ellington
(center) during
an appearance
in the late 1940s.
Reig later went
on to work for
NBC television.

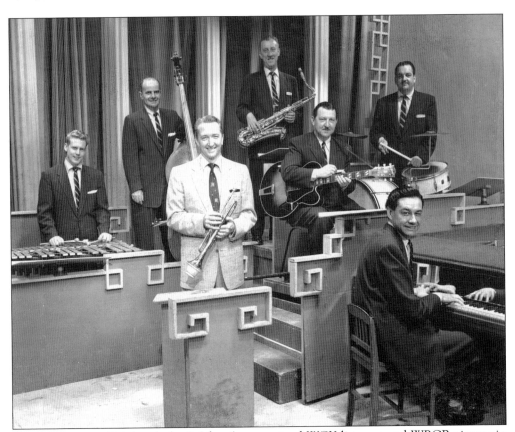

Garry Stevens and his band, the 7 After 6, entertained WGY listeners and WRGB viewers in the early 1950s.

WTRY personality Muriel Haynor is pictured with announcer Paul Flanaghan (left) in this station publicity shot. Later in life, Haynor became a well-known wedding photographer in the Capital Region. The man at right is unidentified.

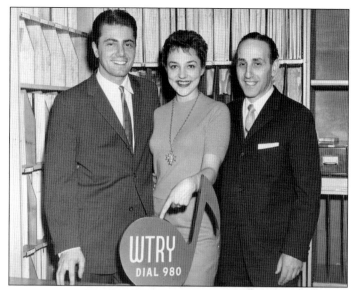

Forrest Willis was a popular announcer in the Capital Region. His career spanned the 1930s until the late 1950s. During that period, Willis worked at WGY, WTRY, and WOKO as the host of a program called *The Musical Clock*. He was also a newscaster at WTRI-TV channel 35 and later at WAST-TV channel 13. Here, WTRY chief engineer Al Chismark (left) and general manager William Ripple (right) present Willis with an award.

Always in competitive mode, WTRY mounted a campaign to present high-fidelity broadcasts to the Capital Region in the mid-1950s. This 1954 photograph shows, from left to right, announcer Paul Flanaghan, general manager Nick Carter, Al Chismark, station owner Col. Harry Wilder, and Joe Roulier listening to a rather large radio. (From the author's collection.)

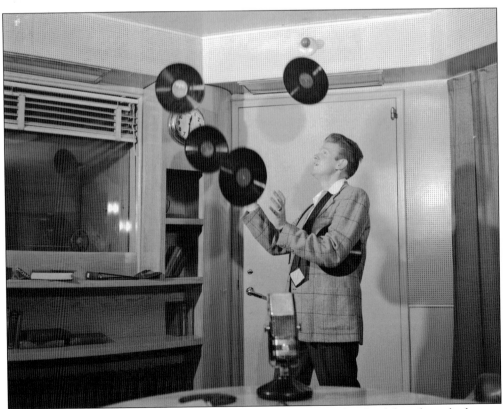

WGY morning man Vern Cook juggles 78 rpm records in the studio. Cook later branched out to television at WRGB channel 6. From the broken record on the table, it appears he was having limited success at juggling.

WGY and General Electric were on the cutting edge of technology. In this photograph from the early 1940s, announcer Howard Tupper broadcasts an ice-skating event from Schenectady's Central Park using a remote studio link strapped to his back and outfitted with microphone and headphones.

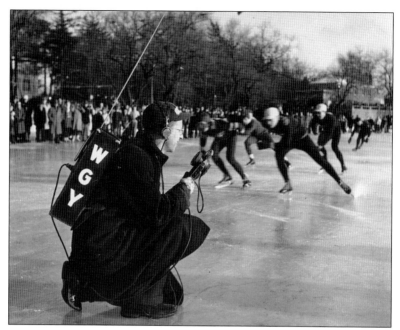

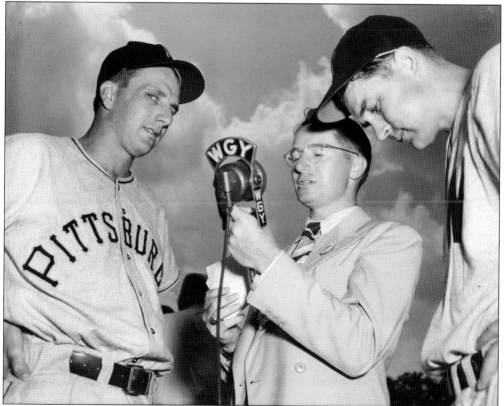

During a live broadcast from the National Baseball Hall of Fame in Cooperstown, WGY sports announcer Bob Hanes (center) interviews future hall of famer Ralph Kiner (left) of the Pittsburgh Pirates.

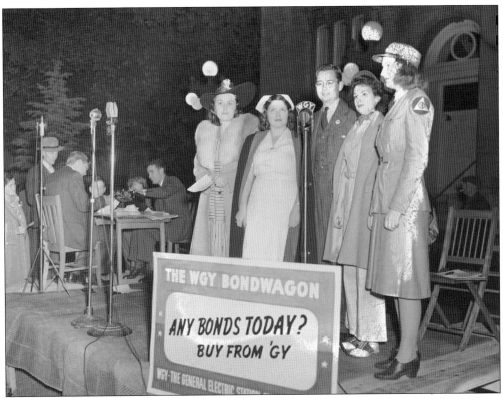

WGY kept the home fires burning during World War II by sponsoring purchases of war bonds at public events.

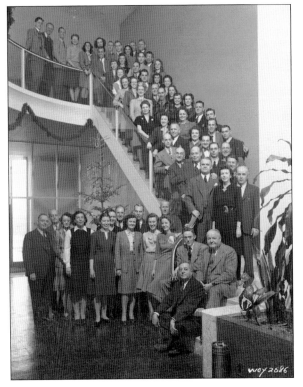

In radio's heyday, it took a huge staff to operate a radio station the size of WGY. Besides the on-air staff, there were engineers, secretaries, sales people, copywriters, typists, audio producers, and electricians. This Christmas card photograph, taken at the WGY studios in the late 1940s, shows the enormity of the station's staff.

In the early 1950s, WPTR struggled to find an audience. Signing on with 10,000 watts with spotty reception in areas of the Capital Region, the station attempted different marketing tactics, including this one for a women's program to rival Martha Brooks's popular show on WGY. The station found its stride after moving up to 50,000 watts and offering a Top 40 format in the mid-1950s.

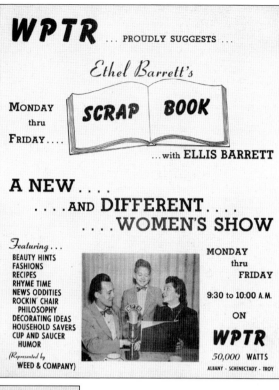

WPTR ... PROUDLY SUGGESTS ...

Ethel Barrett's

MONDAY thru FRIDAY.... **SCRAP BOOK**

...with ELLIS BARRETT

A NEW....
....AND DIFFERENT....
....WOMEN'S SHOW

Featuring...

BEAUTY HINTS
FASHIONS
RECIPES
RHYME TIME
NEWS ODDITIES
ROCKIN' CHAIR
PHILOSOPHY
DECORATING IDEAS
HOUSEHOLD SAVERS
CUP AND SAUCER
HUMOR

(Represented by WEED & COMPANY)

MONDAY thru FRIDAY

9:30 to 10:00 A.M.

ON

WPTR

50,000 WATTS
ALBANY - SCHENECTADY - TROY

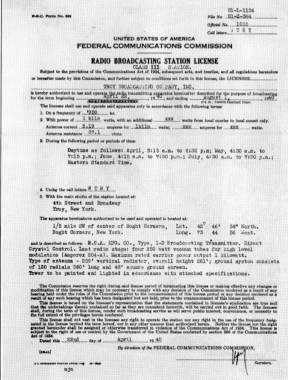

This is the original broadcast license for WTRY. Note that the power output of the station is listed as "1 kilo" watts (1,000 watts). The transmitter location is listed as Boght Corners, the approximate site of the intersection of Routes 9 and 9R, in the area of Guptill's Roller Skating Rink.

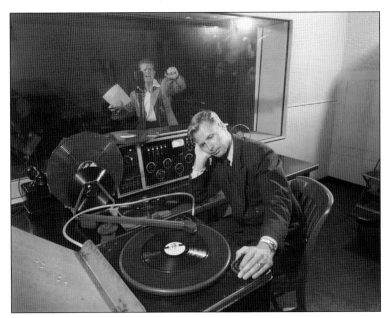

One of a radio announcer's greatest fears is "dead air," when no sound at all is going out over the air. Seconds can turn into what feels like minutes. Vern Cook was a popular morning man on WGY in the late 1940s. In this publicity photograph, Cook (behind the glass) is in obvious panic as the engineer stares off into space.

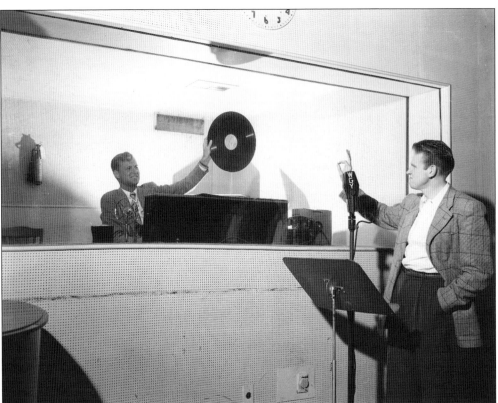

In this posed photograph, WGY morning man Vern Cook motions to the engineer to play a particular record. The disc seen here was called an electronic transcription, or E.T. These 16-inch discs (as opposed to standard 10-inch or 12-inch discs) were produced exclusively for radio stations and contained commercials, programs, and even station jingles.

Four

1956–1963

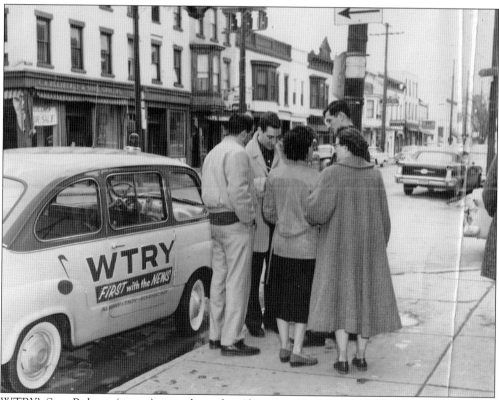

WTRY's Stan Roberts (center) visits the authors' hometown of Waterford. The photograph depicts the corner of Third and Broad Streets in the village. The interesting-looking micro-mini van sporting the WTRY logo is a Fiat 600 Multipla.

This photograph of Don Weeks is from his days as night announcer on WTRY in the early 1960s. Weeks inherited the morning show on WTRY after Stan Roberts left to work in Buffalo. Weeks worked at WAST channel 13, WABY, and announced the morning show on WGY for over 30 years.

George Lezotte, a well-respected news reporter, worked at several Capital Region stations. This is a publicity photograph taken when he worked at WTRY in the early 1950s.

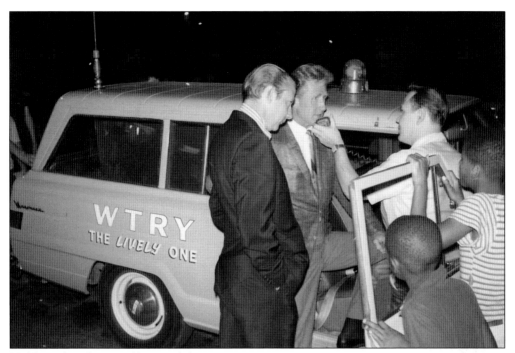

Unlike today, the use of live, mobile technology was cutting-edge radio in the 1960s. Here, WTRY program director Lee Gray interviews television star Lloyd Bridges while on a visit to the Capital Region. Bridges was the star of *Sea Hunt*, an action-adventure program in the late 1950s.

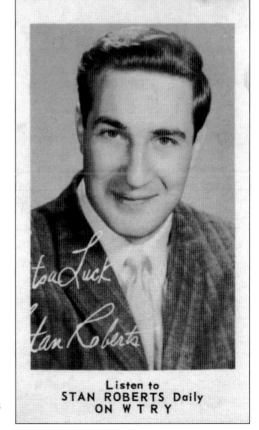

Listen to
STAN ROBERTS Daily
ON WTRY

In order to promote certain announcers, radio stations would print small cards with a picture identifying an announcer and station. This card from WTRY promotes popular early-1960s morning man Stan Roberts.

New! Clever! Timely

SINGING WEATHER REPORTS

Something different is on the air—starting this week! Now you can hear what the weather will be — in merry, lilting tunes. This delightful new musical way of announcing the weather is brought to you by City & County Savings Bank 3 times each week day over **WABY**. Listen in. Hear the C & C weather man, and his girl, tell if the weather will be hot or cold, clear or stormy.

CITY & COUNTY *Savings Bank*
FOUNDED 1850
100 State Street, Albany 1, N.Y.
Member Federal Deposit Insurance Corporation

WABY

MONDAY 8:00 A. M.
THROUGH 12:30 P. M.
SATURDAY 6:45 P. M.

As a gimmick for advertisers, WABY introduced regularly scheduled singing weather forecasts.

Rick Snyder was the popular nighttime announcer on WTRY in the mid-1960s. WTRY presented itself as a professional operation and often dressed its staff in blazers with the station logo. The logo, a triangle with each angle representing the "Tri Cities" of Albany, Schenectady, and Troy, was a familiar one for many years. This photograph shows Snyder at a remote broadcast for a Jiffy King Sub Shop. (Courtesy Joe Condon.)

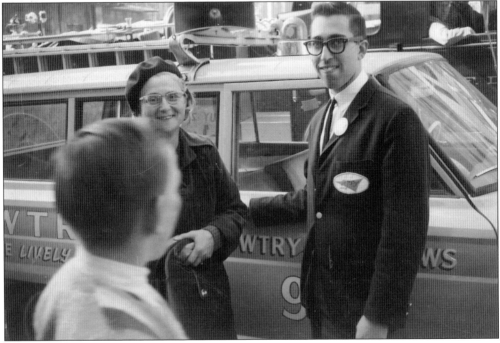

Popular WTRY announcer Dick Brown is seen in a publicity photograph from the late 1950s. Brown worked at WSNY in Schenectady in the early 1950s. (Courtesy WTRY archives.)

WTRY announcer "Tall Paul" James is seen here in the mid-1950s. James later transitioned to WROW during the station's brief Top 40 era. (Courtesy WTRY archives.)

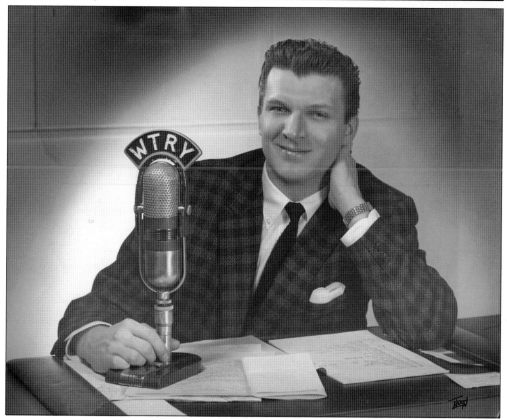

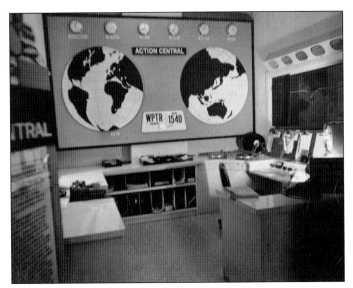

This photograph from the early 1960s shows a WPTR news studio including a world map and international clocks. (Courtesy Kip Grant.)

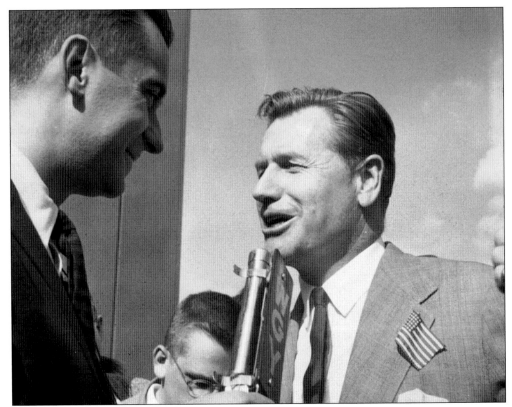

Ernie Tetrault started his career in the Capital Region at WTRY as a part-time staff announcer. He quickly moved from radio to television, at WRGB channel 6, where he hosted an early-morning program. In the 1970s, he moved to Channel 6 News, where he became one of the Capital Region's most well-known personalities.

Through much of the 1950s and all of the 1960s, Bill Edwardsen was WGY's morning man. His slow and deliberate delivery, combined with a sarcastic wit, was wildly popular. Edwardsen also loved jazz. Here, he talks with the great Dave Brubeck (left) about his 1959 album.

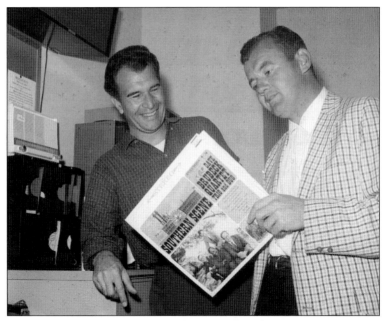

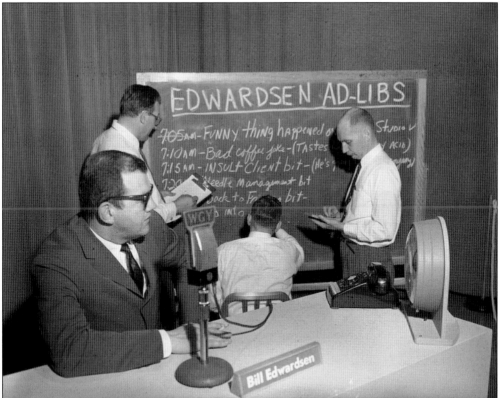

Bill Edwardsen was the very popular host of *Breakfast with Bill* on WGY from 1954 until 1970. Edwardsen was known for his love of jazz music and for a slow, deliberate style of speaking. He often made caustic on-air comments about just about anything, insulting sponsors and station management and espousing political causes.

Billy Duffy, a familiar voice to WGY listeners, did double duty at associated television station WRGB. Duffy started at Schenectady's WSNY and worked at WTRY as news director in the mid-1960s. He was known for his pointed political reporting and commentary. He died at the young age of 47 in 1987.

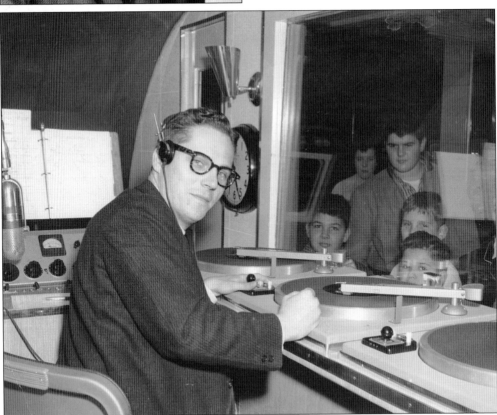

In this late-1950s photograph, WTRY's mobile unit fascinates audience members as an announcer broadcasts. The mobile unit, prone to vandalism and providing unreliable service, was taken out of commission by the early 1960s. (Courtesy WTRY archives.)

The WTRY mobile studio used in the 1950s was designed to resemble a satellite. Its use was limited, as vandals frequently rocked the vehicle while it was in operation, causing tone arms to go flying off of records—a most disconcerting experience for the announcer on duty.

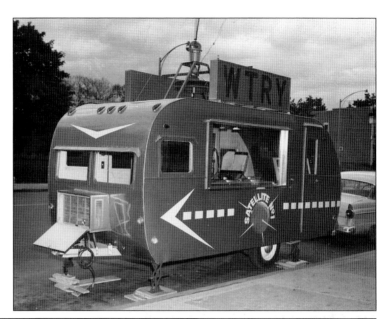

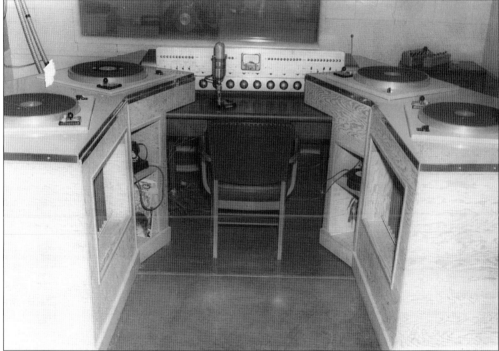

By the late 1940s, radio studios became more user-friendly. Unlike the early days of radio, when the operator running the sound mixing and transmitter controls might be sitting amid a mass of exposed wiring, heat-producing tubes, and transformers, studios became more streamlined. The announcer could manage the controls and announce the program at the same time. This late-1940s photograph of a WTRY studio indicates an efficient design. The control mixer and microphone are at a height the announcer could easily reach while seated. The turntables, which were used for playing musical selections and recorded commercials, are conveniently located within reach. Telephone and records are right below the controls. (Courtesy WTRY archives.)

Don Decker's career started at WSNY. He was WTRY's news director in the early 1950s, later moved to WGY, and then switched to television at WTEN channel 10 and WRGB channel 6. (Courtesy WTRY archives.)

In the late 1950s, WTRY announcer "Tall" Paul James climbed the statue of Gen. Philip Sheridan outside the capitol building in Albany. (Courtesy WTRY archives.)

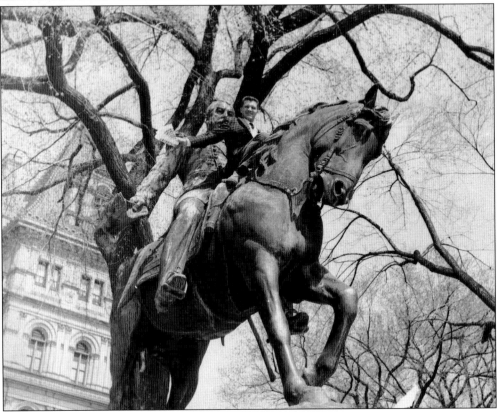

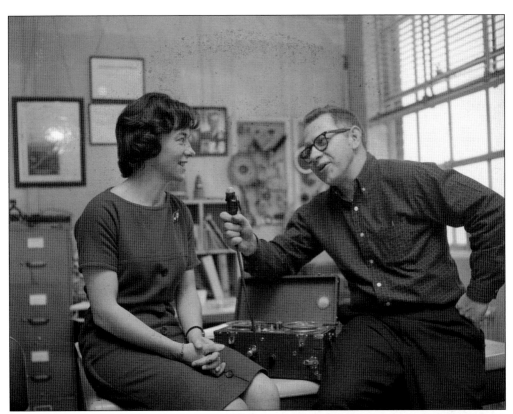

Steve Fitz was a popular broadcaster in the Capital Region, with a career spanning several decades. He started at Schenectady's WSNY in the 1940s, where he created his well-known *Party Line* program in 1952. In the late 1960s, he went over to WGY. Fitz was on WQBK during the 1970s and 1980s and also worked in television at WMHT channel 17. He was known for his engaging and folksy style. Here, Fitz uses a portable tape recorder to interview a young woman at General Electric.

James Delmonico was a well-regarded manager at General Electric Broadcasting from the 1960s through the 1980s, and he was vice president and general manager of WGY, WGFM, and WRGB-TV. Delmonico was particularly known for his philanthropic work in the Capital Region.

Throughout the 1960s, WTRY solidified its news image by offering a large newsgathering and reporting team, frequent newscasts, and the use of mobile units. The WTRY helicopter, flown by pilot Walt Glass (seen here), made possible frequent reports on traffic jams and special events.

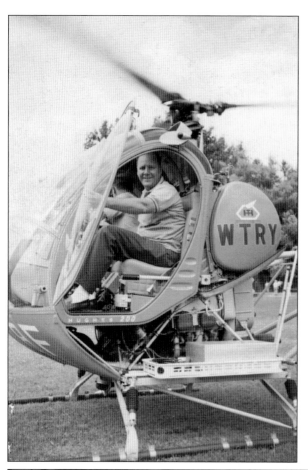

In 1961, WGY moved into new studios with co-owned television station WRGB channel 6. WRGB still occupies the building.

In the early 1950s, when radio announcers broadcast in a public area, it was a major event. WTRY took advantage of a promotional opportunity by erecting glass booths in Denby's Troy store. The broadcasting arrangements allowed the public to see not only the on-air personalities but also the technical aspects of radio. The individual in the glass booth to the right appears to be popular announcer Forrest Willis. In the adjacent booth, WTRY's longtime engineer Frank Belaska mans the broadcast controls. (Courtesy John Gabriel.)

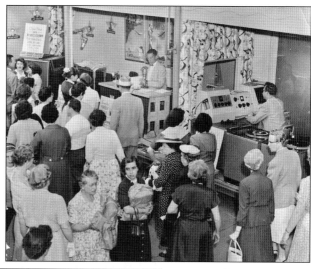

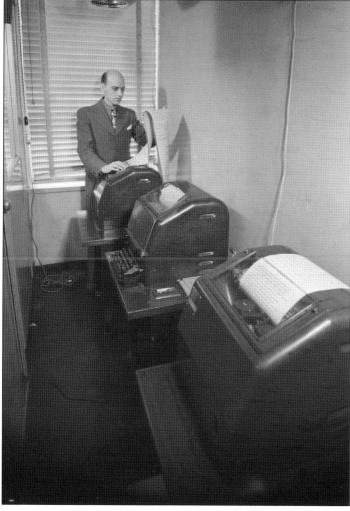

WGY assistant program director Earle Pudney checks the teletype machine. Most radio stations from the 1940s until the 1990s received national, state, and even local news through a teletype machine. Connected by telephone wire to the Associated Press, United Press International, or Reuters News Service, teletype machines provided a continuous feed of news. At times, station announcers would simply tear the printed news stories from the teletype, assemble the stories, and read them directly on the air. Most stations had only one teletype machine. Due to the size of the WGY operation, it had three machines from the major news services. The machines shown here appear to be located in a closet, probably due to their noisy operation.

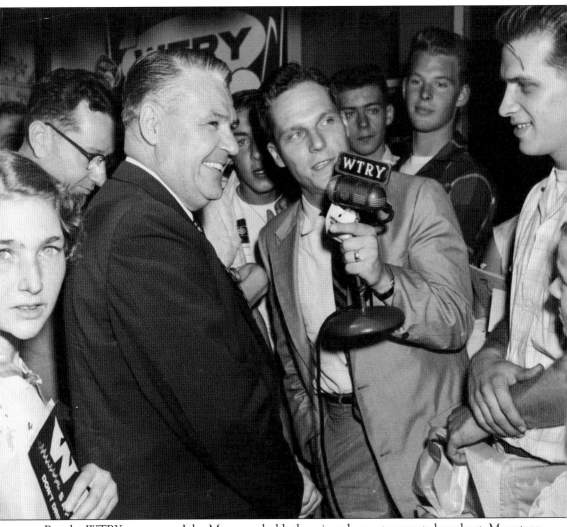

Popular WTRY announcer John Mounteer holds the microphone at a remote broadcast. Mounteer was present in the late 1950s for the station's contemporary music format. He engineered a switch to middle-of-the-road music in the early 1960s and a change back to contemporary music shortly after. (Courtesy John Gabriel.)

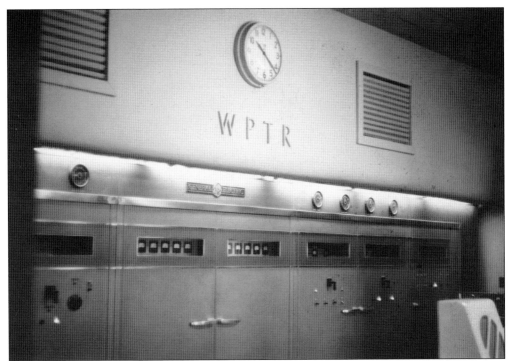

The WPTR transmitter is seen here in the early 1960s. Stations like WPTR and WGY broadcast with 50,000 watts, the highest allowed by the federal government. Stations possessing 50,000 watts generally produce a stronger signal than their competitors. WPTR's broadcast power differed from WGY's, though; WPTR's signal, as authorized by the government, was required to broadcast in a directional manner. WPTR's signal was directed northeast of the Capital Region. By day, the station was heard clearly in Vermont. At night, WPTR added New Hampshire, Maine, Massachusetts, and even Canada as part of its audience. In the Capital Region itself, WPTR struggled to cover the southern and western portions of the area, while several lower-powered competitors easily covered these areas. (Courtesy Kip Grant.)

Many radio stations had separate studios dedicated to the broadcasting of news. The "news booth," as it was called, was often a separate glass studio, built for one person. This 1969 photograph of the WPTR news booth shows the microphone, a small control board where the news announcer could adjust the volume of the microphone and other sources, and two cartridge machines, where pre-recorded commercials or sound could be played on the air. The glass was necessary so that the control room announcer could be signaled. (Courtesy Kip Grant.)

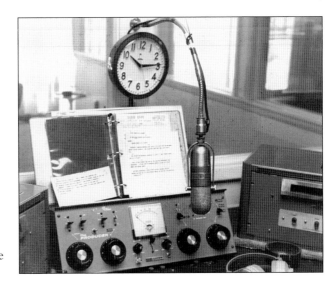

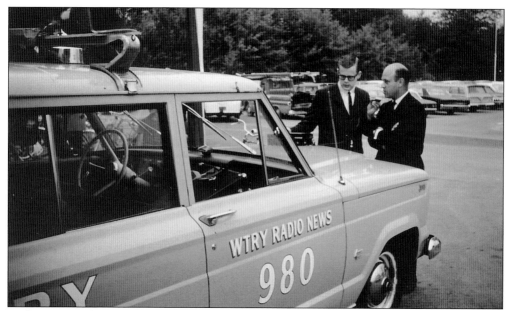

In the 1950s and 1960s, radio stations often had mobile units equipped with the ability to record audio. In this photograph from the early 1950s, WTRY's news director Don Decker is shown interviewing an unidentified man. Note the loudspeaker on top of the vehicle, undoubtedly used to broadcast the station to passersby.

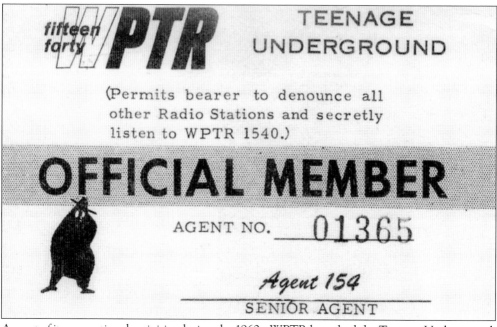

fifteen forty WPTR

TEENAGE UNDERGROUND

(Permits bearer to denounce all other Radio Stations and secretly listen to WPTR 1540.)

OFFICIAL MEMBER

AGENT NO. ___01365

Agent 154

SENIOR AGENT

As part of its promotional activities during the 1960s, WPTR launched the Teenage Underground. On-air announcements were whispered to the listener. (Courtesy Joe Condon.)

In the 1960s, the Capital Region was a test market for the promotion of new recording artists. Publishing ranked survey lists was a popular way to promote Top 40 music stations. This WABY survey from 1962 indicates many of the listed records as "Tunes heard FIRST on WABY."

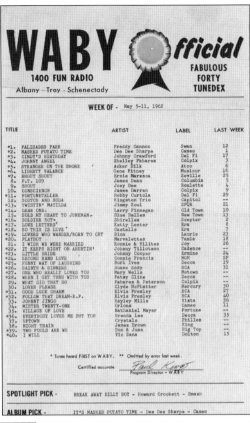

Art Wall was WTRY's news director in the 1950s. He worked with Capital Region radio notables George Lezotte and Don Decker. Wall later migrated to television as news anchor at WAST channel 13. (Courtesy WTRY archives.)

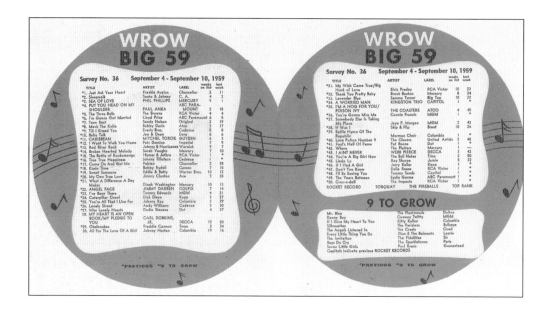

In 1959, WROW abruptly changed its middle-of-the-road format to Top 40. The station featured high-profile announcers, a well-produced station jingle package, and slick marketing. Part of that marketing effort was the production of a weekly music survey. Its competitors also published surveys, but WROW's was of an unique design and was published in color. WROW's experiment with Top 40 ended months later, as it was plagued with contractual obligations to the CBS Radio Network to carry many non–Top 40 programs, like Arthur Godfrey, Ma Perkins, and Art Linkletter's *House Party*. (Both, courtesy Joe Condon.)

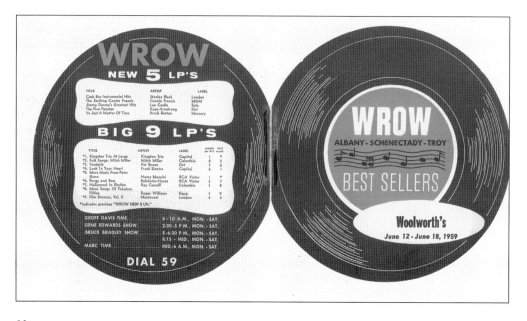

Ed Reilly, who started his career at WICC in Bridgeport, Connecticut, was a popular midday announcer on WTRY for much of the 1960s, working with Don Weeks, Rick Snyder, and Lee Gray. Reilly later worked at WHSH and WABY. (Courtesy WTRY archives.)

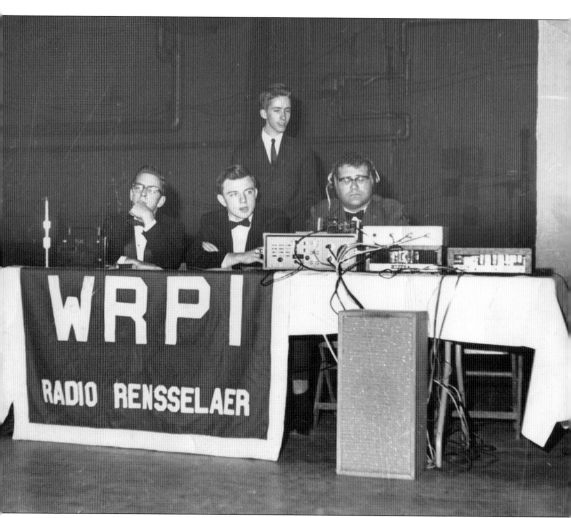

For decades, Ed Dague was the face of television news at WRGB channel 6 and WNYT channel 13. He started his career at WRPI. The station, owned and operated by Rensselaer Polytechnic Institute, featured Dague as a talk-show host in the mid-1960s. He also did play-by-play announcing for the RPI Engineers hockey team. This photograph of a remote broadcast shows Dague, at center in a bow tie, as part of group of broadcasters. (Courtesy RPI Library.)

Five

1964–2011

Station music surveys were commonly printed during the years when Top 40 radio was predominant. WTRY published a high-quality survey on a weekly basis. Jay Clark, pictured on this edition of the survey, was program director of the station in the late 1960s. Clark later went on to program WRKO in Boston, WTIC in Hartford, and WABC in New York. (From the author's collection.)

Lee Gray was a popular WTRY personality in the 1960s. He was program director of the station during the British Invasion and the blackout of 1965.

Bob Connell
6–9 AM

Ed Reilly
9 AM–Noon

Bob Fulle
Noon–3 PM

Lee Gray
3–7 PM

Rick Snyder
7 PM–Midnight

Jay Clark
Midnight–6 AM

Joe Condo
7 PM–1 AM Saturda
9 AM–2 PM Sunda

In the mid-1960s, under program director Lee Gray, WTRY promoted itself as "The Lively One," and the announcers were known as "The Lively Ones." The WTRY "seven most wanted" are pictured in this page from a 1965 promotional brochure.

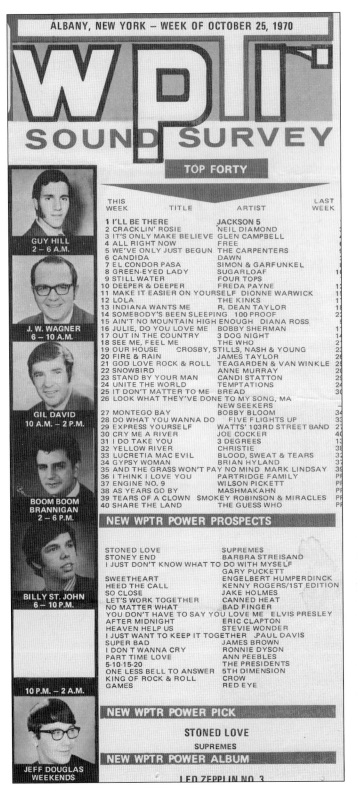

WPTR SOUND SURVEY

TOP FORTY

GUY HILL
2 – 6 A.M.

J. W. WAGNER
6 – 10 A.M.

GIL DAVID
10 A.M. – 2 P.M.

BOOM BOOM
BRANNIGAN
2 – 6 P.M.

BILLY ST. JOHN
6 – 10 P.M.

10 P.M. – 2 A.M.

JEFF DOUGLAS
WEEKENDS

THIS WEEK	TITLE	ARTIST	LAST WEEK
1	I'LL BE THERE	JACKSON 5	
2	CRACKLIN' ROSIE	NEIL DIAMOND	
3	IT'S ONLY MAKE BELIEVE	GLEN CAMPBELL	
4	ALL RIGHT NOW	FREE	
5	WE'VE ONLY JUST BEGUN	THE CARPENTERS	
6	CANDIDA	DAWN	
7	EL CONDOR PASA	SIMON & GARFUNKEL	
8	GREEN-EYED LADY	SUGARLOAF	10
9	STILL WATER	FOUR TOPS	
10	DEEPER & DEEPER	FREDA PAYNE	12
11	MAKE IT EASIER ON YOURSELF	DIONNE WARWICK	15
12	LOLA	THE KINKS	11
13	INDIANA WANTS ME	R. DEAN TAYLOR	18
14	SOMEBODY'S BEEN SLEEPING	100 PROOF	22
15	AIN'T NO MOUNTAIN HIGH ENOUGH	DIANA ROSS	
16	JULIE, DO YOU LOVE ME	BOBBY SHERMAN	17
17	OUT IN THE COUNTRY	3 DOG NIGHT	14
18	SEE ME, FEEL ME	THE WHO	21
19	OUR HOUSE	CROSBY, STILLS, NASH & YOUNG	23
20	FIRE & RAIN	JAMES TAYLOR	26
21	GOD LOVE ROCK & ROLL	TEAGARDEN & VAN WINKLE	25
22	SNOWBIRD	ANNE MURRAY	20
23	STAND BY YOUR MAN	CANDI STATTON	29
24	UNITE THE WORLD	TEMPTATIONS	24
25	IT DON'T MATTER TO ME	BREAD	30
26	LOOK WHAT THEY'VE DONE TO MY SONG, MA	NEW SEEKERS	—
27	MONTEGO BAY	BOBBY BLOOM	34
28	DO WHAT YOU WANNA DO	FIVE FLIGHTS UP	33
29	EXPRESS YOURSELF	WATTS' 103RD STREET BAND	27
30	CRY ME A RIVER	JOE COCKER	40
31	I DO TAKE YOU	3 DEGREES	13
32	YELLOW RIVER	CHRISTIE	38
33	LUCRETIA MAC EVIL	BLOOD, SWEAT & TEARS	32
34	GYPSY WOMAN	BRIAN HYLAND	37
35	AND THE GRASS WON'T PAY NO MIND	MARK LINDSAY	39
36	I THINK I LOVE YOU	PARTRIDGE FAMILY	PP
37	ENGINE NO. 9	WILSON PICKETT	PP
38	AS YEARS GO BY	MASHMAKAHN	PP
39	TEARS OF A CLOWN	SMOKEY ROBINSON & MIRACLES	PP
40	SHARE THE LAND	THE GUESS WHO	PP

NEW WPTR POWER PROSPECTS

STONED LOVE	SUPREMES
STONEY END	BARBRA STREISAND
I JUST DON'T KNOW WHAT TO DO WITH MYSELF	GARY PUCKETT
SWEETHEART	ENGELBERT HUMPERDINCK
HEED THE CALL	KENNY ROGERS/1ST EDITION
SO CLOSE	JAKE HOLMES
LET'S WORK TOGETHER	CANNED HEAT
NO MATTER WHAT	BAD FINGER
YOU DON'T HAVE TO SAY YOU LOVE ME	ELVIS PRESLEY
AFTER MIDNIGHT	ERIC CLAPTON
HEAVEN HELP US	STEVIE WONDER
I JUST WANT TO KEEP IT TOGETHER	PAUL DAVIS
SUPER BAD	JAMES BROWN
I DON'T WANNA CRY	RONNIE DYSON
PART TIME LOVE	ANN PEEBLES
5-10-15-20	THE PRESIDENTS
ONE LESS BELL TO ANSWER	5TH DIMENSION
KING OF ROCK & ROLL	CROW
GAMES	RED EYE

NEW WPTR POWER PICK

STONED LOVE
SUPREMES

NEW WPTR POWER ALBUM

LED ZEPPLIN NO. 3

WPTR was another Capital Region station that published a weekly music survey. Among those shown in this edition from the fall of 1970 are longtime program director and morning announcer J.W. Wagner, Boom Boom Brannigan, and Billy St. John, who also worked briefly at WTRY under the name of Max Stewart. He went on to work at CKLW in Detroit and WCBS-FM in New York. (Courtesy Joe Condon.)

In the early and mid-1970s, Rick Mitchell (right) was a popular morning personality on WTRY. His fast-paced program featured befuddled traffic reporter Fred Peabody, who was played by announcer Jon Knott (left). (Courtesy WTRY archives.)

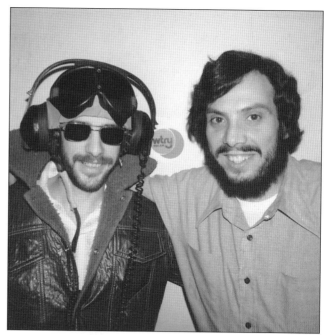

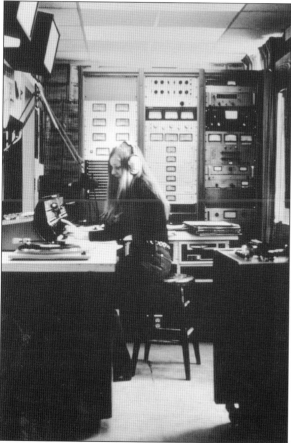

Rensselaer Polytechnic Institute in Troy already had a significant broadcast history with WHAZ, and it began broadcasting in FM in 1957 as WRPI. In 1969, the station updated to stereo broadcasting from a tower located along the banks of the Hudson River in North Greenbush. This photograph from the RPI archives appears to show an announcer named Maria, who played progressive rock late at night. (Courtesy RPI Library.)

Jack Aerneckie started at WGY as a news reporter in 1972. He later moved over to television at WRGB and ended up taking over the anchorman duties after the retirement of Ernie Tetrault in 1993. Aerneckie retired in 2007 after 35 years of service.

Liz Bishop started as a sports reporter for WGY in the 1970s. She was the first female reporter allowed into the locker room of the New York Yankees after the Supreme Court ruled it should be open to women reporters. She quickly moved to anchoring television news on WRGB.

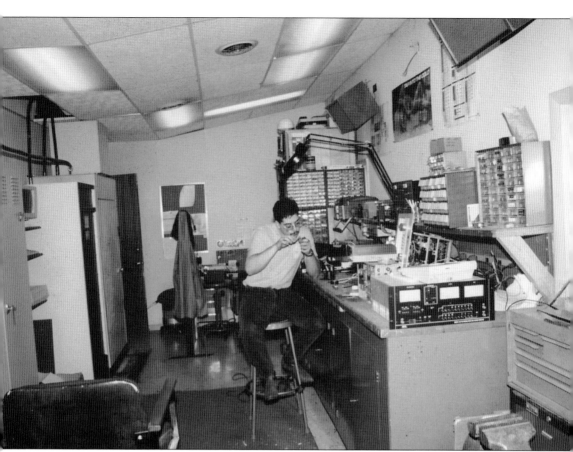

The workspaces of radio engineers are often cluttered with broken equipment and wires. This unidentified engineer seems to be working on a very small component, the most difficult to repair. The small drawer cabinets probably contain diodes, transistors, and tubes of various sizes. Stations now use integrated circuits created by computer, making it difficult to interchange and repair parts.

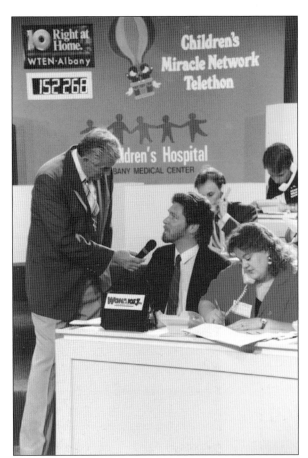

Since the rise of television in the late 1940s and 1950s, radio has used the visual medium as a promotional vehicle. In this photograph from the early 1980s, WTEN-TV anchor Dick Wood (left) speaks on the air with WGNA announcer Walt Adams. (Courtesy WGNA.)

Bob Mason (right) and Bill Sheehan dominated radio ratings in the Capital Region during the 1980s and 1990s. They worked at both WPYX and WQBK. Mason worked in the Capital Region at WCKL in Catskill, WOKO in Albany, and WFLY in Albany. (Courtesy WGNA.)

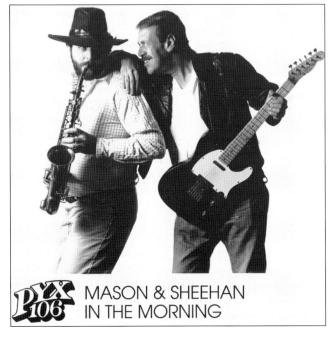

WPTR, along with the other Top 40 music stations in the Capital Region, published a weekly survey for promotional purposes. Note that the now-classic song "Black Magic Woman" was listed as a Power Pick for that week.

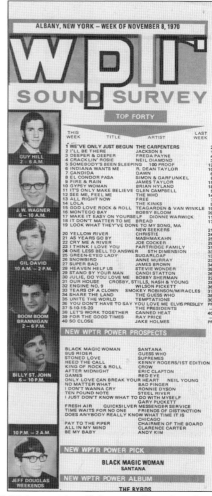

ALBANY, NEW YORK – WEEK OF NOVEMBER 8, 1970

WPTR SOUND SURVEY

TOP FORTY

GUY HILL
2 – 6 A.M.

J. W. WAGNER
6 – 10 A.M.

GIL DAVID
10 A.M. – 2 P.M.

BOOM BOOM
BRANNIGAN
2 – 6 P.M.

BILLY ST. JOHN
6 – 10 P.M.

THIS WEEK	TITLE	ARTIST	LAST WEEK
1	WE'VE ONLY JUST BEGUN	THE CARPENTERS	2
2	I'LL BE THERE	JACKSON 5	1
3	DEEPER & DEEPER	FREDA PAYNE	4
4	CRACKLIN' ROSIE	NEIL DIAMOND	3
5	SOMEBODY'S BEEN SLEEPING	100 PROOF	12
6	INDIANA WANTS ME	R. DEAN TAYLOR	10
7	CANDIDA	DAWN	6
8	EL CONDOR PASA	SIMON & GARFUNKEL	8
9	FIRE & RAIN	JAMES TAYLOR	15
10	GYPSY WOMAN	BRIAN HYLAND	18
11	IT'S ONLY MAKE BELIEVE	GLEN CAMPBELL	5
12	SEE ME, FEEL ME	THE WHO	14
13	ALL RIGHT NOW	FREE	7
14	LOLA	THE KINKS	9
15	GOD LOVE ROCK & ROLL	TEAGARDEN & VAN WINKLE	19
16	MONTEGO BAY	BOBBY BLOOM	20
17	MAKE IT EASY ON YOURSELF	DIONNE WARWICK	11
18	IT DON'T MATTER TO ME	BREAD	17
19	LOOK WHAT THEY'VE DONE TO MY SONG, MA	NEW SEEKERS	21
20	YELLOW RIVER	CHRISTIE	24
21	AS YEARS GO BY	MASHMAKAHN	25
22	CRY ME A RIVER	JOE COCKER	29
23	I THINK I LOVE YOU	PARTRIDGE FAMILY	31
24	ONE LESS BELL TO ANSWER	5TH DIMENSION	33
25	GREEN-EYED LADY	SUGARLOAF	13
26	SNOWBIRD	ANNE MURRAY	23
27	SUPER BAD	JAMES BROWN	34
28	HEAVEN HELP US	STEVIE WONDER	39
29	STAND BY YOUR MAN	CANDI STATTON	26
30	JULIE, DO YOU LOVE ME	BOBBY SHERMAN	22
31	OUR HOUSE	CROSBY, STILLS, NASH & YOUNG	28
32	ENGINE NO. 9	WILSON PICKETT	36
33	TEARS OF A CLOWN	SMOKEY ROBINSON/MIRACLES	37
34	SHARE THE LAND	THE GUESS WHO	38
35	UNITE THE WORLD	TEMPTATIONS	30
36	YOU DON'T HAVE TO SAY YOU LOVE ME	ELVIS PRESLEY	PP
37	5-10-15-20	THE PRESIDENTS	
38	LET'S WORK TOGETHER	CANNED HEAT	40
39	FOR THE GOOD TIMES	RAY PRICE	
40	SO CLOSE	JAKE HOLMES	PP

NEW WPTR POWER PROSPECTS

BLACK MAGIC WOMAN	SANTANA
BUS RIDER	GUESS WHO
STONED LOVE	SUPREMES
HEED THE CALL	KENNY ROGERS/1ST EDITION
KING OF ROCK & ROLL	CROW
AFTER MIDNIGHT	ERIC CLAPTON
GAMES	REDEYE
ONLY LOVE CAN BREAK YOUR HEART	NEIL YOUNG
NO MATTER WHAT	BAD FINGER
I DON'T WANNA CRY	RONNIE DYSON
TEN POUND NOTE	STEEL RIVER
I JUST DON'T KNOW WHAT TO DO WITH MYSELF	GARY PUCKETT
FRESH AIR	QUICKSILVER MESSENGER SERVICE
TIME WAITS FOR NO ONE	FRIENDS OF DISTINCTION
DOES ANYBODY REALLY KNOW WHAT TIME IT IS	CHICAGO
PAY TO THE PIPER	CHAIRMEN OF THE BOARD
ALL IN MY MIND	CLARENCE CARTER
BE MY BABY	ANDY KIM

10 P.M. – 2 A.M.

NEW WPTR POWER PICK

BLACK MAGIC WOMAN
SANTANA

NEW WPTR POWER ALBUM

THE BYRDS

JEFF DOUGLAS
WEEKENDS

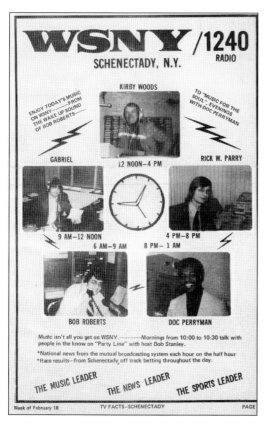

WSNY /1240

SCHENECTADY, N.Y. RADIO

KIRBY WOODS

ENJOY TODAY'S MUSIC ON WSNY——FROM THE WAKE UP SOUND OF BOB ROBERTS

TO "MUSIC FOR THE SOUL" EVENINGS WITH DOC PERRYMAN

GABRIEL 12 NOON–4 PM RICK W. PARRY

9 AM–12 NOON 4 PM–8 PM
6 AM–9 AM 8 PM–1 AM

BOB ROBERTS DOC PERRYMAN

Music isn't all you get on WSNY——Mornings from 10:00 to 10:30 talk with people in the know on "Party Line" with host Bob Stanley.

*National news from the mutual broadcasting system each hour on the half hour
*Race results—from Schenectady off track betting throughout the day.

THE MUSIC LEADER THE NEWS LEADER THE SPORTS LEADER

Week of February 18 TV FACTS–SCHENECTADY PAGE

WSNY, licensed to Schenectady and with a power output of 1,000 watts, always stood in the shadow of General Electric's WGY, at 50,000 watts. In 1967, the station switched from a long-standing middle-of-the-road format to Top 40. WSNY's original presentation was unusual. Billing itself as "The Home of the Young Americans" and featuring announcers with the names of past presidents like George Washington and Tom Jefferson, WSNY at first challenged, and then struggled to compete with, the larger-powered signals of WTRY and WPTR. This early-1970s advertisement in the *Schenectady Gazette* offers information about the station after the Young American concept was abandoned. It features author John Gabriel as one of the announcers. (Courtesy John Gabriel.)

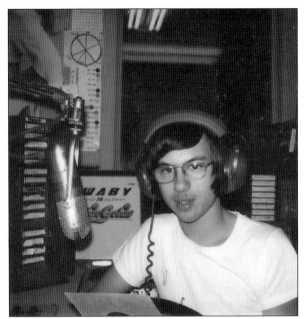

Lou Roberts, a familiar voice in the Capital Region, worked at several stations, including WTRY, WPTR, and WGNA. This photograph shows Lou at age 15 on the air at WABY. (Courtesy Lou Roberts.)

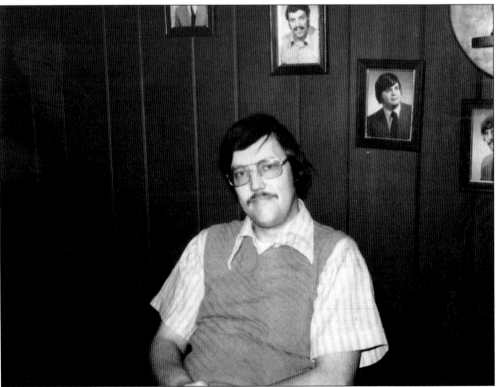

Dan Martin started out as an announcer on WTRY in the 1960s using the on-air name Mikki Martin. He left the station and then returned as Dan Martin. He was program director and afternoon host on WTRY during much of the 1970s. Martin's programming style, which emphasized on-air consistency of sound and music, made WTRY successful for years, despite competition from several FM stations.

The New HUC

1230 AM • 93.5 FM

Sometimes, small suburban radio stations can impact a larger market. Such was the case with WHUC in Hudson, about 30 miles south of the Capital Region. In the 1970s, the station's stylized Top 40 sound influenced radio presentation across the country. This is the cover of a WHUC weekly music survey from the 1970s.

WTRY program director Lee Gray hands a check to an unidentified listener. Gray, an expert at promotions and public relations, brought WTRY consistently high ratings in the Top 40 radio war with WPTR. (From the author's collection.)

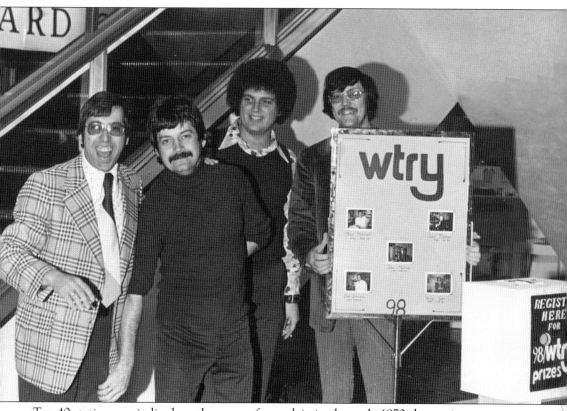

Top 40 stations capitalized on the wave of nostalgia in the early 1970s by staging announcer reunions. Shown here are, from left to right, Rick Snyder, Jay Clark, Don Berns, and program director/afternoon host Dan Martin. (Courtesy Joe Condon.)

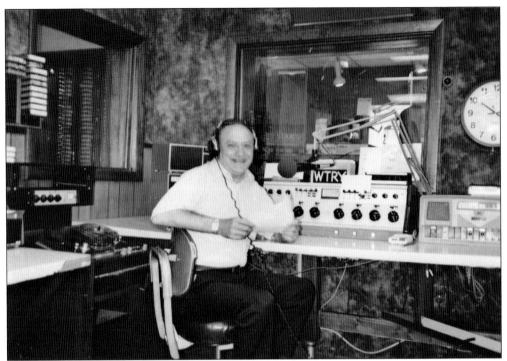

Lou Tinney was a newscaster at WTRY from the 1960s through the 1980s. He was also known for work in television, including his role as the Capital Region's "Bozo the Clown" on WAST channel 13 in the late 1960s. (Courtesy WTRY archives.)

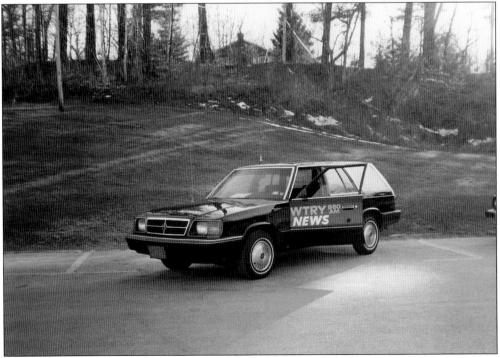

The WTRY news car is seen here in the mid-1980s. (Courtesy WTRY archives.)

Allan B. Shaw Jr. was a popular night announcer on WPTR in the mid-1960s. This picture of Shaw in the control room at WPTR in the 1960s clearly shows the oversized turntables commonly used at the time. Later in his career, Shaw went to work for ABC, programming a New York City station. He was later elevated to senior management positions at ABC. He had a long radio career. (Courtesy Allan Shaw.)

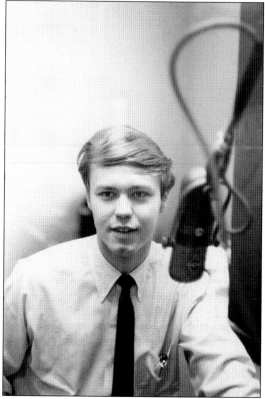

Chuck Phelan was an announcer on WPTR during the 1960s. Phelan was a student at Rensselaer Polytechnic Institute who helped the college station WRPI convert to modern stereo broadcasting in 1969. His air name was "Chuck Phillips." (Courtesy Kip Grant.)

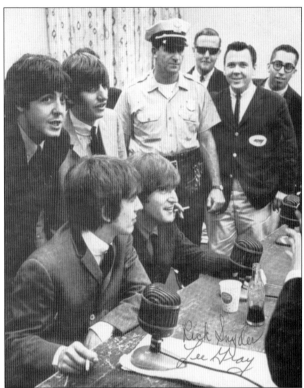

WTRY's largest promotion during the 1960s was a station-sponsored trip to meet the Beatles in London. Program director Lee Gray went to extremes to become "Beatle Buddy Lee Gray." Here, Gray (in the blazer with the station logo) and announcer Rick Snyder (far right) are pictured attending a Beatles press conference.

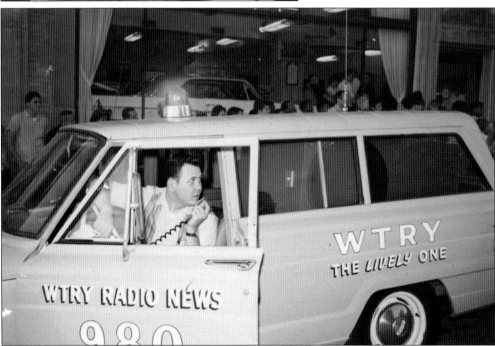

The news reputation that WTRY had built in the 1950s under program director Nick Carter continued well into the 1970s. In this candid photograph from the mid-1960s, WTRY program director Lee Gray broadcasts from the station's mobile unit.

WTRY's mobile broadcasting unit is pictured here in the mid-1970s.

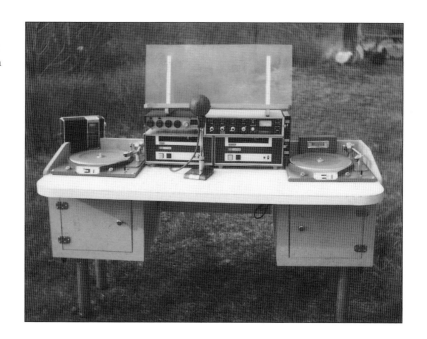

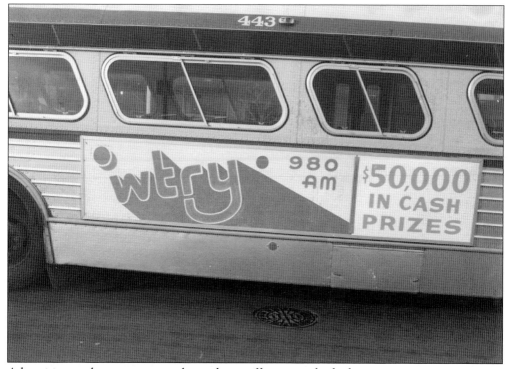

Advertising on buses was a popular and cost-efficient method of promotion in comparison to television, newspapers, and direct mail. WTRY and co-owned WHSH used "bus cards" to advertise. (Courtesy WTRY archives.)

In 1974, WTRY staged a reunion of 1960s announcers. Pictured here are John Mounteer (left), program director and announcer on WTRY in the early 1960s; Ed Reilly (center), longtime WTRY announcer, who also worked at WABY and WHSH; and Bob Stevens, the WTRY announcer at the station controls. (From the author's collection.)

A THANK YOU for listening from "Boom Boom"

I didn't know whether you wanted a Cadillac, a BMW, a Mercedes or a Porsche... so I got you a shiny new **Lincoln!**

"Boom Boom" Brannigan
6-10 am ~ Legends Radio
WPTR 1540 AM

WPTR's Boom Boom Brannigan was the Capital Region's king of self-promotion. He broadcast on WPTR from the 1960s until the 1970s. His personal appearances at fairs, record hops, and weddings were major events. "The Boomer" handed out pennies in an effort to promote his return to WPTR in the early 2000s. (Courtesy Kip Grant.)

Roy Reynolds was the midday announcer and program director at WPTR in the late 1960s. This publicity photograph shows Reynolds in WPTR's main studio, known as the "Gold Studio." To the right of Reynolds is the control board, where the announcer could adjust the volume of music, commercials, and other sound sources. Reynolds is pulling a tape cartridge from one of the playing machines in front of him. The cartridge might have contained a recording of a station jingle, a commercial, or even a song. A stack of cartridges is on top of another player in the foreground. (Courtesy Kip Grant.)

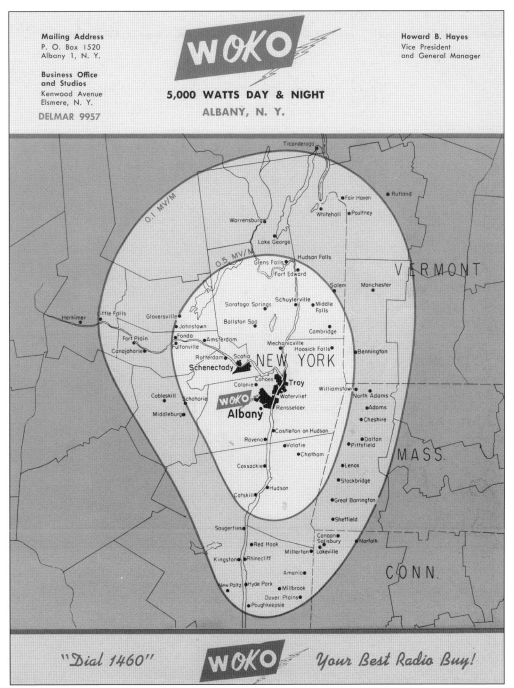

Since commercially viable radio began in the late 1920s, stations have used coverage maps to visually explain their size, signal strength, and audience reach. Each station used its own standards for indicating signal coverage, so there was little standardization between coverage maps. This 1970s coverage map of WOKO in Albany was used for marketing. (Courtesy Kip Grant.)

John Gabriel has been a long-standing announcer in the Capital Region, working at WFLY, WSNY, WABY, WPTR, and, his longest-lasting stint, at WTRY. Gabriel is seen here in the mid-1980s at WTRY. (From the author's collection.)

WHSH started as FM station WDKC in the 1960s. The station featured an eclectic mix of oldies, pop standards, and big band music. In the 1970s, the station went through several format changes, from a part-time rebroadcast (know as "simulcast") of sister station WTRY, to oldies (twice), and to beautiful music, also known as "elevator music" (twice). In the early 1980s, the station became WPYX, "PIX-106," and it has remained a popular station since that time. (Courtesy Joe Condon.)

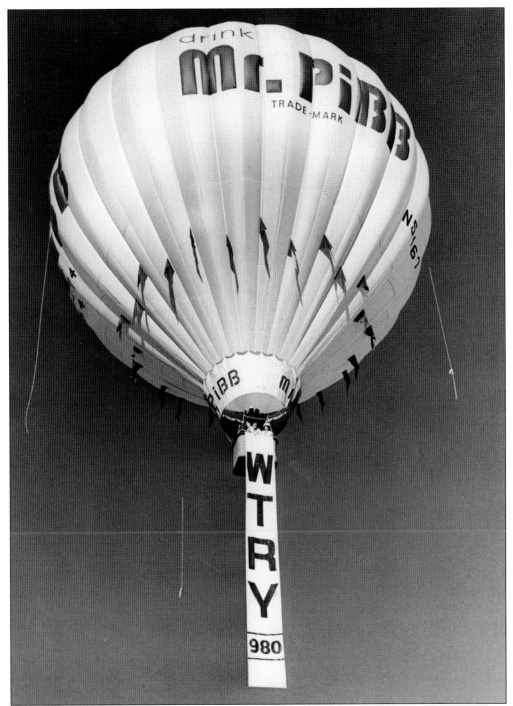

Radio station promotions could sometimes be far-reaching. Shown here is a WTRY promotion from the early 1980s featuring afternoon announcer Dan Martin waving from a balloon promoting the soft drink Mr. Pibb. (From the author's collection.)

WTRY is one of the few radio stations in the country that has its own road, in the town of Niskayuna, New York. Located off Route 7 (Troy-Schenectady Road), the long, meandering road leads to the WTRY towers. The towers are located in a swampy area at the end of the road. Swampy areas are ideal transmitting sites for AM broadcast stations. AM radio stations' transmission power is largely based on several factors. One is the power output (in watts) of the station, two is the length of the broadcast tower properly tuned to the frequency of the station, and three is the conductivity of the ground around the structure of the tower. There is always a large grid of underground wires constructed around the tower. Ground conductivity is particularly best where the soil is wet, spongy, and preferably near a body of water like a bog, swamp, or river. (From the author's collection.)

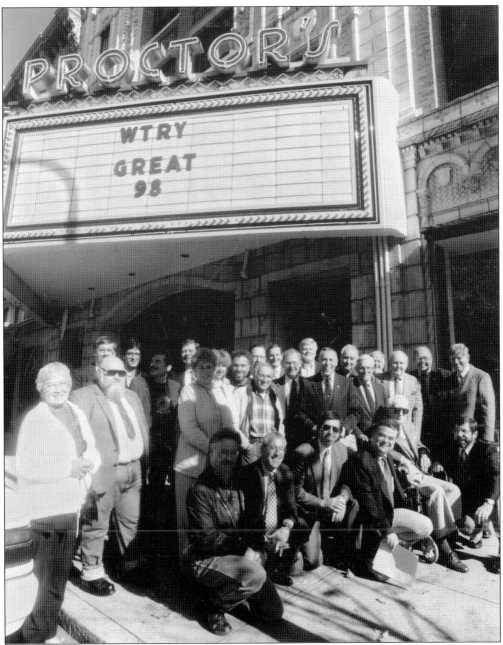

In October 1993, former staff members from WTRY assembled in front of Proctor's Theatre, the original location of WTRY in Troy. Among those pictured are Rick Snyder, Don Weeks, Ed O'Brien, Rip Rowan, George Lezotte, Ric Mitchell, Ed Reilly, Joe Condon, and John Gabriel. (Courtesy Joe Condon.)

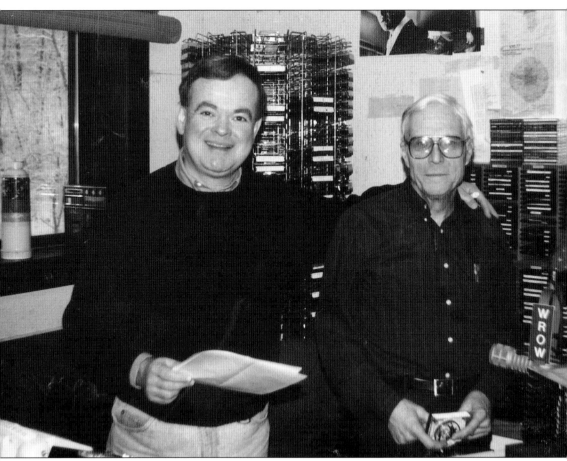

In 1993, Joe Condon (left) invited WTRY radio legend John Mounteer (right) to the WROW studios. In the late 1950s and early 1960s, Mounteer helped transform WTRY from a station featuring largely network programming to a locally programmed Top 40 format. (Courtesy Joe Condon.)

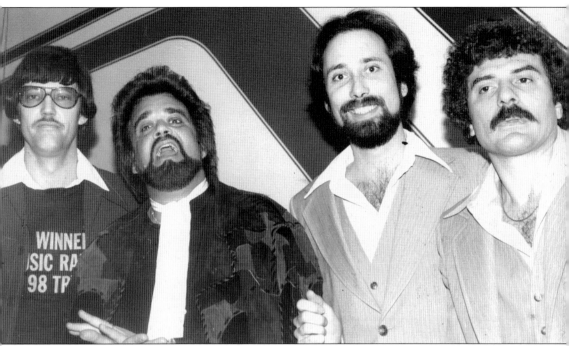

In the mid-1970s, Wolfman Jack was hosting *The Midnight Special* on the NBC Television Network. During this time, he was distributing several radio programs to stations around the country. He visited WTRY in order to promote a pre-recorded program he hosted on the station. Pictured here are, from left to right, program director Dan Martin, Wolfman Jack, and announcers Don Perry and Jerry Tyler. (Courtesy Joe Condon.)

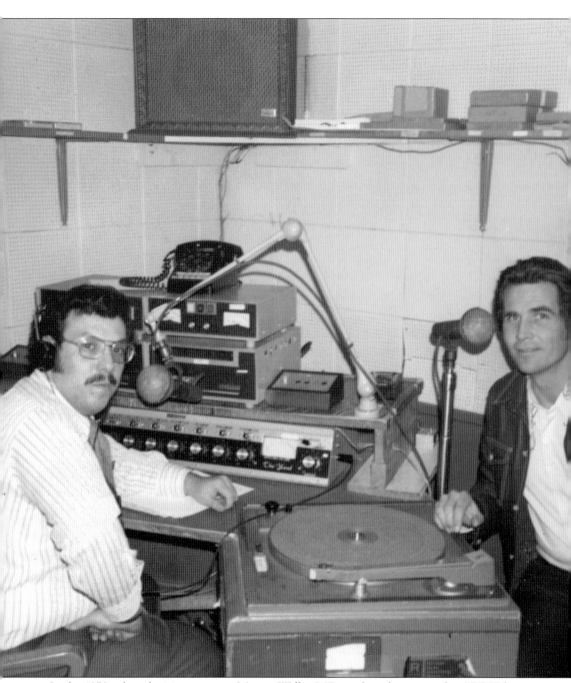

In the 1970s, the television program *Marcus Welby, MD* was broadcast over the ABC Television Network. Starring Robert Young and James Brolin, the show received high ratings. Here, WTRY's Ric Mitchell (left) interviews costar Brolin in the WTRY production studio in Troy. Besides being an actor in his own right, Brolin is the father of popular actor Josh Brolin. The pictured Brolin is married to Barbra Streisand. (Courtesy Joe Condon.)

Remote broadcasts have been an important part of broadcasting since the very beginnings of the medium. The earliest remote broadcasts involved a microphone wired to a portable transmitter. By the 1980s, remote broadcasts went big, with large billboard backgrounds and cases and giant inflatable displays. The Capital Region's country music station, WGNA-FM, went all-out with its traveling WGNA Money Machine. Pictured are announcers Richie Phillips (left) and program director Fred Horton, who solidified WGNA's country format, which continues to this day. He worked not only in the Capital Region, but in New York City, Utica, Rochester, and Hartford, Connecticut. Horton passed away in 2008. (Courtesy WGNA.)

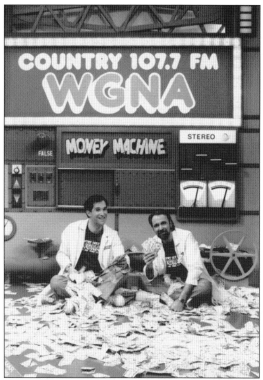

This photograph from the early 1980s shows an elaborate remote setup for country station WGNA. (Courtesy WGNA.)

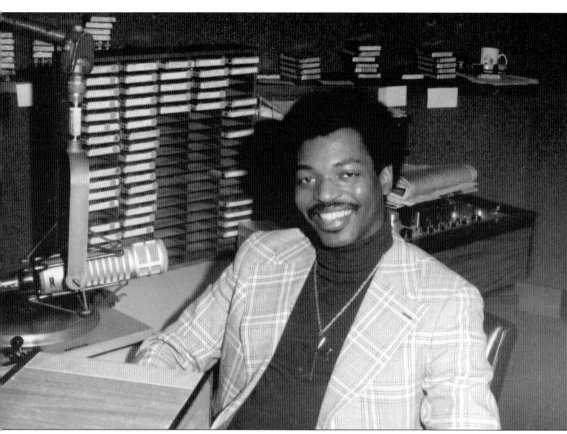

Doc Perryman was a well-known announcer at WGY in the 1970s and 1980s. He started at WSNY in Schenectady in the 1960s with a specialty soul music program. Perryman continues to entertain through live performances in the Capital Region.

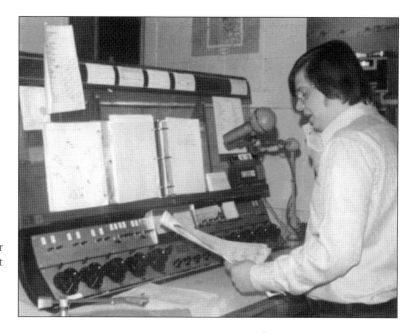

This book's coauthor, John Gabriel, is seen here announcing on WTRY in the early 1970s. Gabriel has been an enduring radio personality in the Capital Region for decades. Starting in the early 1970s at WFLY, Gabriel worked at WSNY and WABY before spending the better part of his career at WTRY. (Courtesy Lou Roberts.)

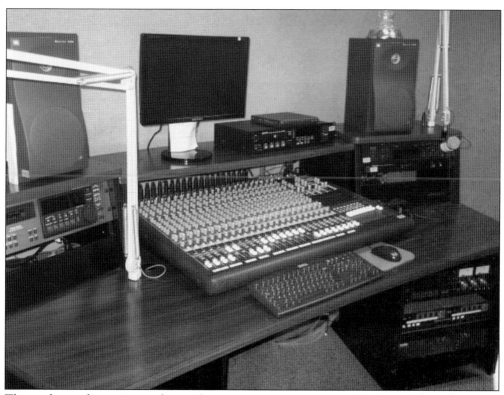

The modern radio station studio combines compact space, computerized controls, and an array of buttons and volume controls for mixing.

In the early 1960s, WPTR, in an obvious marketing association with Coca-Cola, released a record called "Song of Troy." One of the song's writers is indicated as "Ramsburg," who was announcer Jim Ramsburg of WPTR. Also produced were a "Song of Schenectady" and a "Song of Albany." (Courtesy Chip Ordway.)

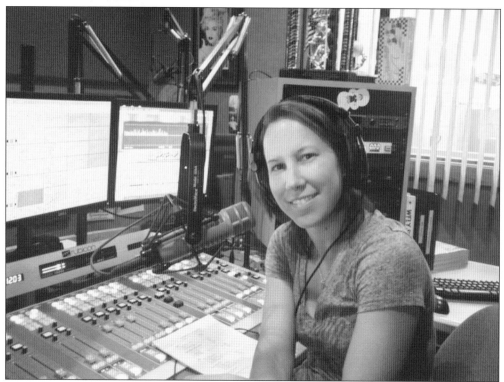

WFLY signed on in the early 1950s. The station was owned by the *Troy Record* newspaper. From its beginnings until the late 1960s, the station offered a strict format of classical music. In the late 1960s, the station began a slow transition toward popular music. In the summer of 1970, WFLY switched to a format of oldies and Top 40 hits. In the years following, the station went through several ownership and format changes. In the late 1970s, WFLY rediscovered its Top 40 niche, and it has not turned away from it since. The station is currently operated by Albany Broadcasting and is housed, along with sister stations WROW, WYJB, WKLI, WZMR, and WAJZ, in Latham. Shown here is WFLY's afternoon announcer, Marissa, on FLY 92.3. The studio Marissa works in is typical of radio stations these days, with banks of computer screens and flashing lights. WFLY still offers a high-energy contemporary format. (From the author's collection.)

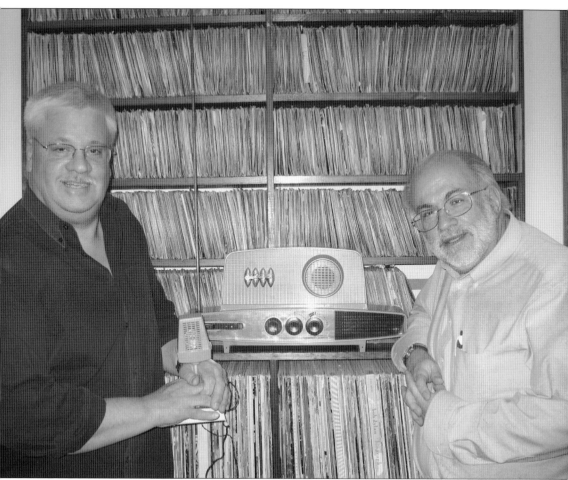

Capital Region Radio: 1920–2011 authors John Gabriel (left) and Rick Kelly stand in Gabriel's home studio with a Remco Caravelle transmitter/receiver. Manufactured in the 1960s, the Remco Caravelle was used by Gabriel and Kelly as a transmitter for their pirate station, operated in Waterford and Troy, New York, in the late 1960s and early 1970s. (Courtesy Kathy Wheeler.)

DISCOVER THOUSANDS OF LOCAL HISTORY BOOKS FEATURING MILLIONS OF VINTAGE IMAGES

Arcadia Publishing, the leading local history publisher in the United States, is committed to making history accessible and meaningful through publishing books that celebrate and preserve the heritage of America's people and places.

Find more books like this at
www.arcadiapublishing.com

Search for your hometown history, your old stomping grounds, and even your favorite sports team.